Indianapolis

Indianapolis

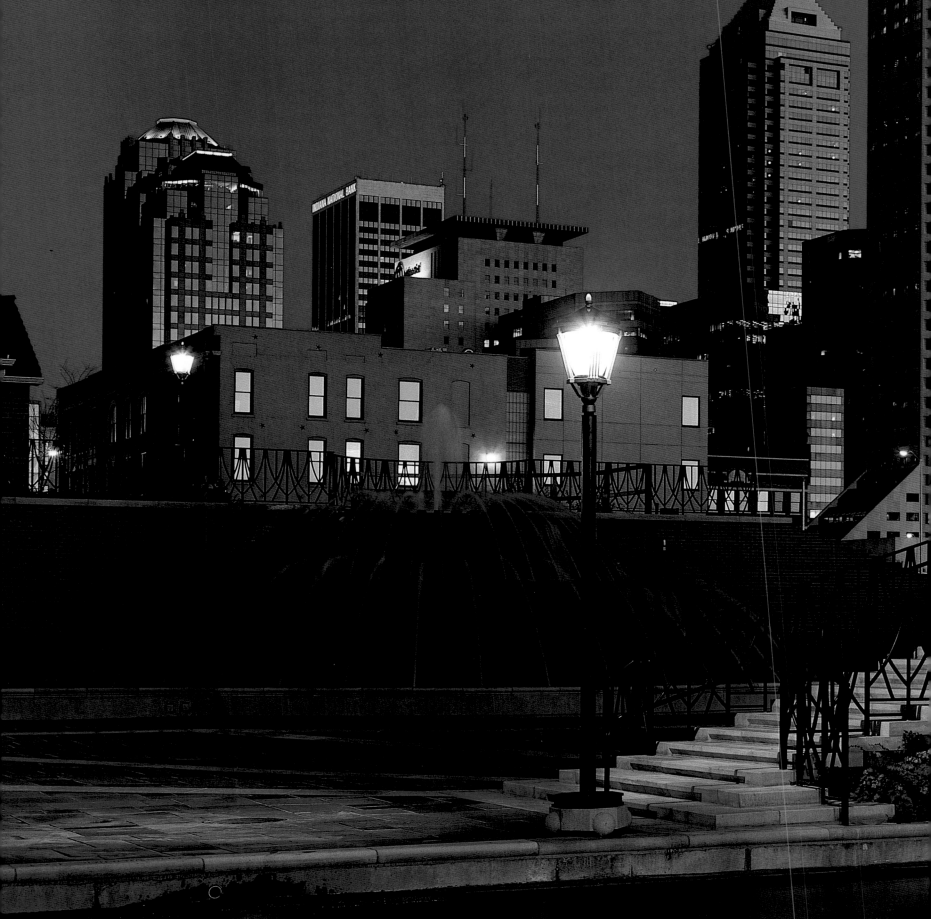

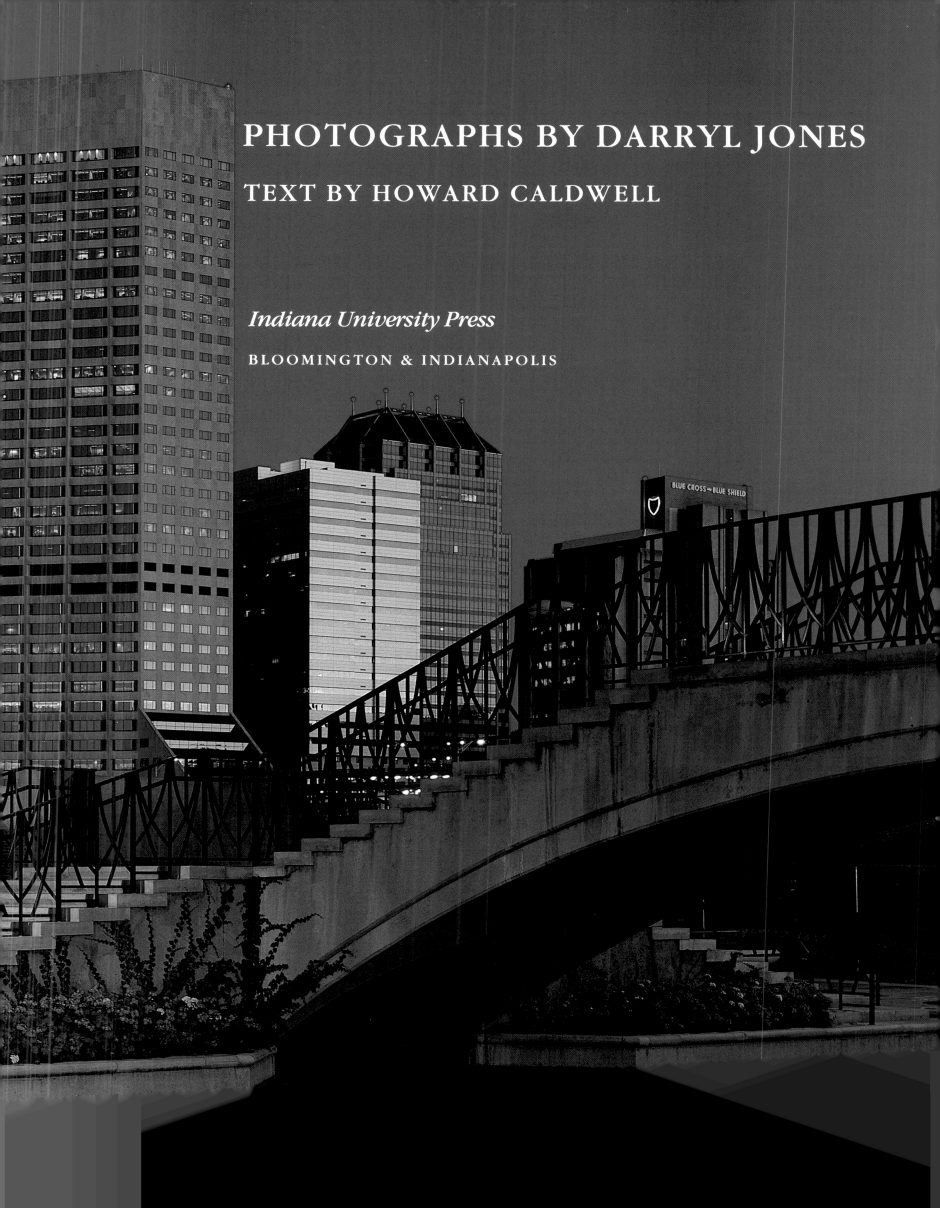

PHOTOGRAPHS BY DARRYL JONES
TEXT BY HOWARD CALDWELL

Indiana University Press

BLOOMINGTON & INDIANAPOLIS

Library of Congress Cataloging-in-Publication Data

Jones, Darryl.
 Indianapolis / photographs by Darryl Jones; text by Howard Caldwell.
 p. cm.
 ISBN 0-253-32998-1
 1. Indianapolis (Ind.)—Description—Views. I. Caldwell, Howard, date. II. Title.
F534.I343J66 1990
779′.99772′52043—dc20 90-4659
 CIP

 2 3 4 5 94 93 92 91 90

Editor: Kenneth Goodall
Designer: Matt Williamson
Managing editor: Terry L. Cagle
Production coordinator: Harriet Curry
Typeface: ITC Garamond
Compositor: G & S Typesetters, Inc.
Printer: C & C Offset Printing Co., Ltd.

To my wife, Nancy; my children, Aaron and Hannah;
my parents, Mr. and Mrs. William B. Jones, Jr.;
and my parents-in-law, Mr. and Mrs. C. William Grepp.
Darryl Jones

This book is dedicated to my wife, Lynn, and our family.
Howard Caldwell

INTRODUCTION

It was during World War II. I was at the University of Wisconsin, assigned there by the United States Navy to attend radio operator school, when I first heard the words. They went something like this: "Oh, you're from Naptown, are ya?" and "How long have ya lived in India-No-Place?"

Those remarks came spilling out of the mouth of a Navy classmate who grew up in northern Indiana. I'd never heard the terms before, and they hit with considerable impact. It was at that moment that I realized how important my hometown was to me. I had completed nineteen years of living, and up to then I had taken my town for granted. I vowed that if I ever got back to civilian life I would plan it around Indianapolis. After all, the capital of Indiana was for me a city filled with happy memories, numerous interests, and an assortment of friends. It would be my base of operations for pursuing new interests and establishing new memories of friendships yet to be.

Career strategies altered the "stay-in-Indianapolis" plan during most of the 1950s, but since the spring of 1959, when I returned, it has been fully implemented. It happened with some happy additions I didn't include in the original idea: a supportive wife and three very special daughters.

But back to that good-natured classmate, to whom I actually owe much. In the 1940s there was some basis for his blunt critique. The city was a far cry from what it was to become. To me, however, it represented security, assurance, stability—conditions that kept me going in the unfamiliar surroundings of a war.

If my Navy colleague's words of friendly disdain had been uttered in the early 1800s he would have been right on target. At that time, the area was indeed a "no place." It didn't even have a name. A judge in the town of Madison is credited with providing "no place" with the name *Indianapolis*. Jeremiah Sullivan combined the name of the new state, which stands for "land of the Indian," with the Greek word for "city," *polis*. The state legislature at the time had to approve the name, and it apparently did so without much fuss or debate. Legislators liked the idea that *Indianapolis* tied the

name of the state to a term that originated in the birthplace of democracy. It seemed quite suitable in a young nation, still a test case in democracy altered to include a system of representation. As for the first part of the name, its choice is a bit surprising, for at the time there were more Indians than whites in the central part of Indiana, and many whites were uneasy about it. That attitude existed even though by 1820, when Indianapolis was created, the Native American tribes had ceded most of their land to the United States.

Even more surprising was that members of the General Assembly, meeting in what was then the state capital, Corydon, were fearless enough to decide we should be where we are today. In the early 1800s towns that thrived were located along waterways where commercial goods could be exported and imported. That wasn't the case in the central region of the new world's recently admitted nineteenth state. There was a river here, all right, but its ability to serve commerce was considered doubtful at best even then. Within a few years all doubts were removed. The White River's navigational limits were severe.

There were other problems, too. Surface drainage was poor. There were a number of swampy creeks and bayous. These ingredients assured at least annual visits of flooding and malaria. Just getting around wasn't easy. The proposed site was a heavily forested area with paths for roads.

Even the man hired to draw up plans for a community that consisted of a few log cabins thought his work would have little significance. Four square miles had been set aside for the new city, but Alexander Ralston's plan embraced only one square mile. He was convinced the city would never become any larger. The skepticism did not come from a man of inexperience. Ralston had helped Pierre L'Enfant lay out the city of Washington, D.C.

Despite misgivings about the city's future, Ralston and his partner, Elias Pym Fordham, were determined to formulate a distinctive plan. They conceived two basic cross streets, then saw to it that the two principal seats of government were away from the center of the city. The statehouse was to be

two blocks to the west, the courthouse two blocks to the east (now the site of the City-County Building). The main business street, Washington, would run by them, and it would be wider than the other streets. The planners chose a rounded hill of sugar maple trees just north of Washington straddling Meridian Street to suggest a circular meeting spot. Four diagonal streets were added, each ending one block short of the circle. We know them today as Massachusetts, Indiana, Kentucky, and Virginia Avenues. With some slight alterations, the basic plan remains today.

Ralston missed one calculation. His plan called for the governor of the state to live in the center of the Circle. The state built a home there almost immediately, but no governor ever lived in it. The story goes that Governor James Brown Ray's wife took one look at the place and said, in effect, "no way." Ernestine Rose, who wrote a book on the history of the Circle, called the home's interior "poorly planned for home living." But that wasn't the reason Mrs. Ray rejected it. She said everyone in town would be able to inspect her washing on Monday mornings. It took some seventy-five years for the Soldiers and Sailors Monument we know so well today to become the focal point of Monument Circle.

Little by little the decision by the legislators to move the seat of state government from Corydon, the town near the Ohio River where it had existed for only five years, to a newly created city in the center of the state proved to be a wise one. The move encouraged a shift of the population to the previously unpopular upper two-thirds of the state. That shift was bolstered as the Indians were forced out, frequently in shabby fashion.

Another change was taking place in the growing city. The National Road was coming right through the middle of town from east to west. Eventually it extended from coast to coast and became a main thoroughfare for travel and commerce. We know it today as U.S. 40; in town it's Washington Street. As recently as World War II it was the east–west route motorists had to take to get through Indianapolis. I can remember as a youngster watching with fascination the many cars, trucks, buses, streetcars, and interurbans that passed by constantly. My vantage point in the early 1930s was the small porch of the Audubon Court apartments at the southeast corner of East Washington and South Audubon Road. That porch and that apartment complex are still there today.

Historians agree that the real turning point for Indianapolis came in 1847, the city's twenty-seventh year of existence, when the first train arrived. It was operated by the Madison and Indianapolis Railroad with financial assistance from the state. Historian George Geib of Butler University, in his book *Indianapolis: Hoosiers' Circle City,* describes it as a "series of steam-drawn wagons running on wooden rails." It may have been crude, but it and other such trains ended the state's effort to boost the economy by constructing a canal system for the distribution and sale of goods. Fewer than eight of the planned eight hundred canal miles were completed.

Indianapolis figured in all this, and the Central Canal paralleling White River from above Broad Ripple to the downtown area provides the evidence. Fortunately it was acquired long ago by the Indianapolis Water Company and is used as a source of water for the city. It is also the source of some lovely scenery.

Prompt success by the early railroads also led to furious competition. Railroad service proliferated around the state. Historian William Holloway labeled Indianapolis "the Railroad City." Eventually it led to construction of the nation's first Union Station, a facility that served all lines operating in and out of Indianapolis, an innovation for the time. By 1870 some eighty trains were arriving and departing there daily. Nearly thirty-five years after it was built it was torn down and replaced by the structure that still stands today, now restored and altered to serve shoppers and diners. To an older generation it is a reminder of emotional goodbyes and happy arrivals of family members, friends, and lovers.

But back to the 1840s and the arrival of the first train. When it got here Indianapolis was still a small country town of about five thousand people. Thirteen years later, in 1860, the population had more than tripled. There were even more meaningful changes. Business in the new community had been exclusively retail. Now it also included wholesale activity. Hotels, sporting the most modern fashions such as indoor plumbing, began to appear, along with decent restaurants, many of them in the hotels. In the early 1850s a politician, Harvey Bates, built a structure that provided both dining and overnight accommodations. The Bates House at the northwest corner of Washington and Illinois became most successful. Years later it was replaced by another longtime occupant, the Claypool, and today it is the site of the Embassy Suites.

A little farther to the west, at 148 West Washington Street, the growing city's first theater was added to the modest skyline. There had been theater offerings in the city previously, but in 1858 the first building constructed for such a purpose opened for business. It was the Metropolitan Theatre (later the Park), and it offered plays and musicals by traveling companies. The attempt struggled for a few years but eventually picked up a following and survived for nearly eighty years.

Indianapolis was slow to accept theater, partly because many of the churches in town didn't approve. Only five more theaters were added to the downtown scene by 1900, and two of them had limited lives, destroyed by fire. The most significant of the survivors was the English Opera House, built by Indianapolis philanthropist William English. It was constructed along with a hotel on the site of English's former home on the northwest quadrant of Monument Circle. English's opened in 1880 and offered entertainment by most of the celebrated actors and actresses of the next sixty-eight years.

Both English's and the Park hold special meaning for me.

My father used to regale us with stories about the Park's productions, which he reviewed for one of the daily newspapers, the *Indianapolis Sun,* when he was in college. His compensation consisted of tickets to the fancier productions at English's, where he took coeds on dates. Presumably most of those dates were with a college coed he eventually married, my mother, Elsie. Today in the thriving city of Indianapolis there's not a trace of either theater. Both sites are occupied by spanking new office buildings.

James H. Madison, in his book *The Indiana Way,* notes that the 1920 census was the first in the history of the state to show more urban than rural Hoosiers, though just slightly. Folks didn't always come directly from the farm. My grandparents are examples of that.

Ben and Martha Caldwell moved to Indianapolis in 1911 from Lewisville, a small community in eastern Indiana's Henry County. Grandfather was a cabinetmaker and, after spending his life up to then in a rural environment, decided that his future would be far brighter in the state's largest city. He and my grandmother also wanted their son to be the first in the family to go to college. They rented one side of a double a few blocks from Butler University, then in Irvington, on the city's eastside.

Just a few months earlier my maternal grandparents, Edward and Martha Felt, also moved into the Irvington area. They came from Greenfield, another small community to the east, about halfway to Lewisville. Mother's father had been elected to serve on the state appellate court, and he decided it was a good time to move to the city, where he would be closer to the statehouse. He served two terms and later became one of the city's first municipal court judges.

Grandfather Felt was active in Democratic party politics and was elected appellate judge on that party's state ticket after holding a series of elected judicial posts in Greenfield. My father and his parents, on the other hand, were staunch Republicans. Such a split was symbolic of the times. Indiana had been a political swing state since the 1870s. A few thousand ballots either way could determine electoral votes for one or the other political party.

Both families sent their children to Butler, and that's how my parents met. Butler became a permanent commitment for them. They remained active in alumni affairs as long as they lived. Dad always said the university helped him in his transition from small-town to big-city life. The city also convinced him to change the pronunciation of our name. It was pronounced "Ca-*well,*" ignoring the third and fourth letters, L and D. When he was applying for part-time work to help with the costs of college, the personnel manager told him his name should be pronounced like it was spelled, "*Cald*-well." Dad immediately agreed and got the job. It's been pronounced that way in the big city ever since, but a few miles to the east one still finds lots of Ca-*wells.*

To backtrack a bit, Irvington, named for Washington Irv-

ing, happened in 1870 when some people decided they wanted to retreat from the confusion of downtown Indianapolis. It is said that one of the founders greatly admired the man who was considered the nation's first great writer, and the founder's suggestion prevailed. More significantly, the founders convinced Northwestern Christian University that it should move from its heavily forested campus at 13th and North College Avenue to a twenty-five-acre section in what would be one of the city's earliest suburbs. Shortly afterward the school renamed itself Butler after Ovid Butler, prominent Indianapolis attorney and board chairman who wrote the university's charter.

Years ago my father, Howard, Sr., wrote a paper for the Irvington Historical Society about his days at Butler (1911–15). He noted that "Butler College was the pride of Irvington for 53 years." The "marriage" ended when the school outgrew its campus and the city of Indianapolis offered Fairview Park on the northside to replace it. Today that campus is just short of three hundred acres, nearly twelve times the size of the old Irvington site. The Bona Thompson Library building is the only structure left from the old campus, though some of the homes nearby are still identified as former fraternity or sorority houses.

One former student structure still stands on University Avenue. But it is better known as the one-time home of the grand dragon of the Indiana Ku Klux Klan, D. C. Stephenson. The Stephenson era ended with a scandalous trial and a prison sentence for Stephenson. But attitudes consistent with Klan doctrine didn't disappear overnight. Years later I was reminded by a Catholic family that in their view all the old Irvington social and cultural organizations that flourished for years were restricted to Protestants.

Black families lived at the east edge of Irvington, just outside the old boundary line. During the 1940s a contemporary of mine became manager of a neighborhood theater that operated on East Washington Street near the black section. He wanted to admit blacks and publicly made the change of policy known. White patrons complained to the owner, and my friend was fired.

Not until World War II did downtown Indianapolis theaters begin admitting blacks. It was pretty difficult to justify refusing admittance to an African American who was in uniform serving his country. Emma Lou Thornbrough has pointed out, however, that policy didn't bend in many places even then. In an article written for the Indiana Historical Society on "Breaking Racial Barriers," she observed that "when black soldiers ventured into private 'white' restaurants, they were usually refused service."

Of course, such rejection was typical of the time and should not all be blamed on the Klan. Nonetheless, a Klan mentality is generally credited with the establishment of Crispus Attucks High School, which came in the 1920s and suddenly required all black students in the Indianapolis Public Schools to attend, no matter how difficult it was to get

there. We were into the 1960s before laws with strength began to have an effect on school desegregation, public accommodations, employment, and housing. Part of the reason was establishment of a civil rights commission that could deal with complaints.

Unaware of the inequities that were going on around us, we youngsters who grew up in Irvington were generally a happy lot. Winding streets, large impressive trees, and the accessibilities that go with a small-town atmosphere made for a comfortable life. One could get just about anyplace one needed to go on foot or bicycle. Few of us had cars in my growing-up years in the 1930s and early 1940s. We carried newspapers, played ball, ran errands for the family at a collection of shops along Washington Street, and took our best girls to the Irving Theatre for movies and to a nearby ice cream parlor afterward. As we got older one or two of us in our crowd got the family car for transportation if the high school basketball team was on the road. If nothing else worked out we just took our date for a ride on the streetcar.

Life was not limited to Irvington. Indianapolis served many interests, and I pursued them. I began paying substitutes to carry my paper route on Saturdays so I could see the latest big band at the old Lyric Theatre. I wanted to see the show twice, and the family rule required that I be home before nighttime; that left no time to deliver papers. The Lyric is long gone, but one of the theaters I later frequented is still here. The old Circle on Monument Circle was the prime place for big bands in the 1940s. It has now been restored to the finery it sported when it was constructed in 1916 as one of the most notable movie palaces of the time.

I made other trips by streetcar or bus to Victory Field (now Bush Stadium) to play the clarinet in the old Knothole Band. It was a kids' band with a wide range of ages, sizes, and abilities, but the compensation was worth the rehearsals and the many appearances: free admission to the Indianapolis Indians baseball games. Bush Stadium still flourishes today. I also made frequent trips with my family and later with my teenage contemporaries to see Tony Hinkle's football and basketball teams. The historic Butler Bowl and the Fieldhouse (now Hinkle Fieldhouse) became an important part of my life.

Downtown there are still buildings that hold certain memories and have special significance for me. I look at the L. S. Ayres building and wonder how many times I met my mother or sister or friends inside on the first-floor balcony, which supplied chairs for the purpose. Then there's the clock outside, a favorite meeting point in mild weather.

My most poignant memory of Ayres, besides its wonderful Christmas story window displays, was a trip I made with my mother when I was in the eighth grade. It seems that a group of the moms had agreed that the young males in my grade at School 57 should take advantage of Mrs. Gates's ballroom dance training, which included the latest on etiquette. Somehow they pulled it off, and we joined hands in this rather frightening endeavor. Some of the more sophisticated of us took the chance to break the ice with certain young maidens in our class. But there was one devastating point that the mothers had concealed in their sales pitch: we were required to wear white gloves. My mother got me into Ayres en route to a promised downtown movie. I'll never forget the smirking little clerk who waited on us. I made a hurried exit once the sale was consummated. But I still have an affinity for that building, which has been there longer than I can remember.

Another structure with a special meaning for me is the Merchants Bank building, just across the street from Ayres at the southeast corner of Meridian and Washington. Dad went into business for himself in that building in 1921. He was there until the late 1960s. When I walk through the Meridian Street entrance on rare occasions, I still get a feeling that I'm living back in those years. Now the Ayres and Merchants buildings no longer dominate, almost lost in a sea of new construction that fills the downtown area.

One downtown landmark that I finally grew to appreciate is the Soldiers and Sailors Monument. It took on new meaning after I experienced long absences from the area during World War II. But I didn't mention it to anybody at the time, for it did seem a bit maudlin of me.

When I put away my Howe High School textbooks and notebooks to head into military service in 1944, I didn't realize that my Irvington days were over. I never really lived there again, though I sometimes tour the place with old friends or visiting relatives. The homes look pretty much the same. Still there are the home the Caldwell family lived in the longest, the home where mother's parents lived, and the home just a few blocks to the west of Irvington proper, built by Grandfather Caldwell.

Indianapolis's appearance didn't change much during the first thirty-five years of my life. When I came back to live here in the late 1950s with a wife and young children, though, there were some subtle beginnings of change. The streetcars were gone, replaced by more and more automobiles. Residential areas were expanding, primarily to the north and east, and we were in the early stages of shopping centers—the Meadows, Glendale, Eastgate. But downtown was pretty much the same, still the main shopping area. New commercial construction was a rarity. A depression, two wars, and a conservative attitude that rejected federal money kept us pretty much on a path of status quo.

But there was a very big difference for me. I now looked at my hometown from a new perspective, that of a journalist. After returning to civilian life I managed to get a journalism degree at Butler University, and with Butler's help I found my first full-time job on a small-town newspaper. My newspaper career ended when I was called back into the Navy for additional active duty in the Korean conflict. After that came an introduction to broadcast news in Terre Haute.

I soon found that it was sometimes difficult to separate the journalistic from the personal perspective. There was the time, for example, when I passed by Union Station and saw myself with my parents and sister fifteen years earlier waiting for the signal to board a train that would return me to military life. Some memories never leave.

In 1959 the Democrats were in charge of City Hall. Mayor Charles Boswell was an able, hard-working politician who found himself presiding over the inevitable decline of downtown retail business, a problem that was occurring in every sizable city in the country. The suburban shopping malls got bigger and better and more numerous. Their easy parking was a tremendous attraction to a now auto-oriented shopper. On top of that, more and more residents fled to suburban areas as the inner city deteriorated. Within a few years all the old downtown movie theaters were gone except the Circle and the Indiana, whose neglected maintenance matched that of much of the downtown housing. Four long-time retail outlets held fast: L. S. Ayres, H. P. Wasson, William H. Block, and L. Strauss. But all of them opened more successful branches in the shopping centers. Author Madison has provided us with a telling comparison. In the late 1950s, he found, six downtown stores accounted for 90 percent of the department store sales in Marion County; by 1972 that percentage was down to 18.

It was all very depressing to me at the time. Yet I contributed to the change as much as anyone else. We located our home in what was then considered suburbia and found the shopping malls most convenient. But I still wanted my daughters to know something about how it used to be. We made a point of going on shopping trips at Christmas time to the stalwart retailers downtown. Ayres and Block's both still had those special street-window holiday scenes, and both still supplied a Santa Claus. We also made it to a few family film musicals at Loew's and the Lyric (before they closed in the 1960s) and the Circle. Some old interests of mine were still in place: the baseball park and the Butler Bowl and Fieldhouse. The family became loyal followers of the Indians and the Bulldogs.

We lost Mother to illness a little over two years after our return to Indianapolis. She had played a strong part in my life, especially in guiding me early in how to cope with problems. She also had been a strong supporter of my various Indianapolis interests and career pursuits.

Some half-dozen years later I became aware that Dad was going to various social functions with a widow whose son was a member of the Indianapolis School Board. Dad and Bertha Lugar were married shortly after her son, Dick, was first elected mayor of Indianapolis.

That put me in an unusual position. I was anchoring TV news at Channel Six at a time when the norm was single anchors. I presented all the stories on the early and late evening news; TV reporters were more involved then in writing than in presenting news. Richard Lugar was a young, vigorous mayor with innovative ideas that prompted a lot of coverage. There were many stories about him, and every time I read one I felt that in all probability someone in the viewing audience figured I was just promoting my newly acquired stepbrother. Actually I was excited about the energy that seemed to be reviving the city I enjoyed so much, but I realized I must continue in the neutral role I'd been trying to maintain since going on TV in Terre Haute back in 1954. The solution was quite simple, but it wasn't always obvious to some, I'm sure. We had an assignment editor who determined what was to be covered at City Hall (the new City-County Building by this time), and he was guided in his decisions by the reporter who covered that beat. I just stayed out of the whole process.

Some of the groundwork for what was ahead for Indianapolis started in the 1960s. It was intriguing to be in the role of describing these developments for TV viewers. One of the first manifestations was the City-County Building that replaced the old Courthouse and City Hall. During Mayor Boswell's time a drive for further capital improvements pushed ahead. Boswell's successor, John Barton, began clearing away the resistance to federal aid and established a blue-ribbon committee for advice and help. It was called the Greater Indianapolis Progress Committee, and it continues to play a vital role in city planning.

The great outburst of change in Indianapolis came in the 1970s and 1980s. Controversy has accompanied it. The changes have involved using federal money and tax incentives, once a no-no. They have also involved displacing people, invariably low-income people, to make way for such ambitious projects as an inner belt to deal with the many interstate highways that feed into Indianapolis. Displacement also was involved in the acquisition of land on the westside for what has become the third largest university in the state, Indiana University—Purdue University at Indianapolis. The changes also have involved politics. Uni-Gov put most of Indianapolis and Marion County under a single government to more easily deal with the tax structure and government assistance programs. It also helped keep Republicans in control of practically all local government offices. A very charismatic Republican picked up on Lugar's pace beginning in 1976. William Hudnut has been elected to the job four times.

Out of all these changes, most of them the result of cooperation between the public and private sectors, has come a skyline that my grandfathers I'm sure would have thought impossible. It contains a host of impressive new office buildings (Bank One Center Tower, American United Life, Market Tower, Capital Center, and others), sports facilities (Hoosier Dome, Market Square Arena, Indiana University Natatorium), hotels (Westin, Hyatt Regency, Embassy Suites), and restorations (Union Station, City Market, Circle and Indiana Theatres, Indiana Roof Ballroom). In addition there's a Convention Center and a wide choice of dining and entertainment facilities. Still in the works is perhaps the most controversial

of all, the downtown Circle City Mall, to further convince people that retail shopping can be done just as well downtown as at suburban shopping centers.

Into the midst of this downtown metamorphosis came Photographer Darryl Jones, chosen to help document the changes by the Indianapolis Metropolitan Arts Council because of his perceptive talent. Jones's first pictures in the downtown series were of a ceremony observing completion of the landscaping of the World War Memorial Plaza. He calls it a conversion of the plaza from a "blacktop" motif to one of beauty, with flora that includes grass and many trees. Sometime afterward Jones was picturing the Monument Circle brick project and the addition of lamps around the Circle's perimeter. These were the first of many downtown beautification projects he observed in detail, and he found himself getting wrapped up in what was happening. A downtown was coming back to life.

After his Arts Council association ended, Jones was still called upon by the city for his talent. Every two years or so he photographs the Indianapolis skyline from the same vantage point to show how much it has changed since the last time. One of his scenes is on display in the conference room outside the mayor's office in the City-County Building.

Jones, however, has not confined himself to the central part of the city. He has taken his many cameras to various neighborhoods, to college campuses, to parks, to suburban areas where vigorous expansion continues. In these travels he has also looked for faces, faces that tell a story.

Darryl Jones and I are very different people, and yet we have a great deal in common. We are both Hoosiers with an emotional attachment to our capital city. And in both cases it happened after we had lived long enough to make comparisons.

While this book was in preparation, the results of two surveys about Indianapolis were revealed. The first one proclaimed that our town was the "epicenter of boredom." The second one—based on such criteria as crime, health care, the environment, transportation, education, the arts, recreation, climate, and terrain—declared that of 333 metropolitan areas, Indianapolis ranked 30th. As someone who has lived here most of his life, the second survey seems a lot closer to the truth. If that adds up to boredom, I like it.

And wherever you are, old Navy buddy, I want you to know that this definitely is "India-SOME-place" now.

Indianapolis

The appearance of the Indianapolis skyline remained virtually unchanged for decades until the 1960s. Each decade since then has brought a substantial increase in new structures. This telephoto view from across White River looking east toward downtown clearly shows that the skyline champion in terms of height is now the Bank One Center Tower.

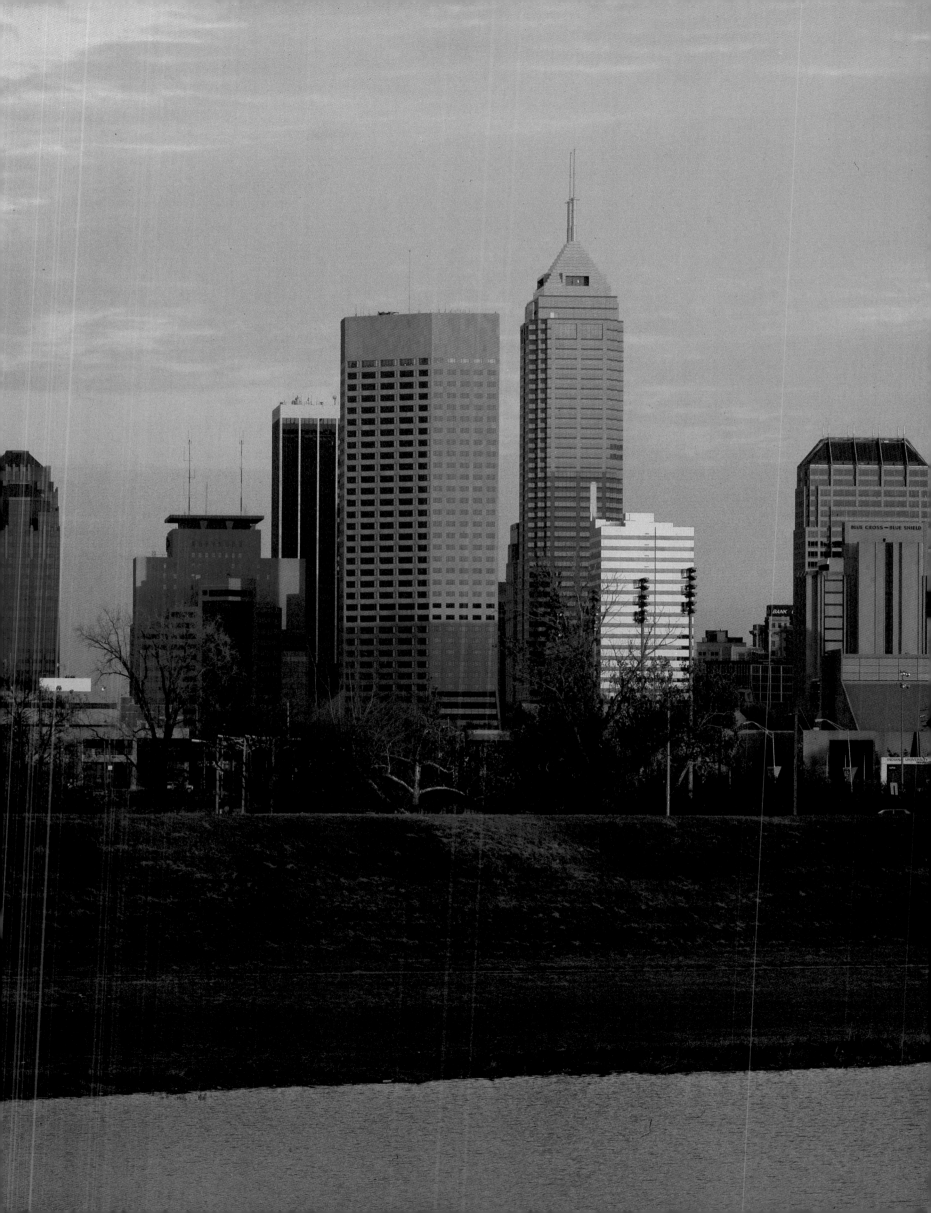

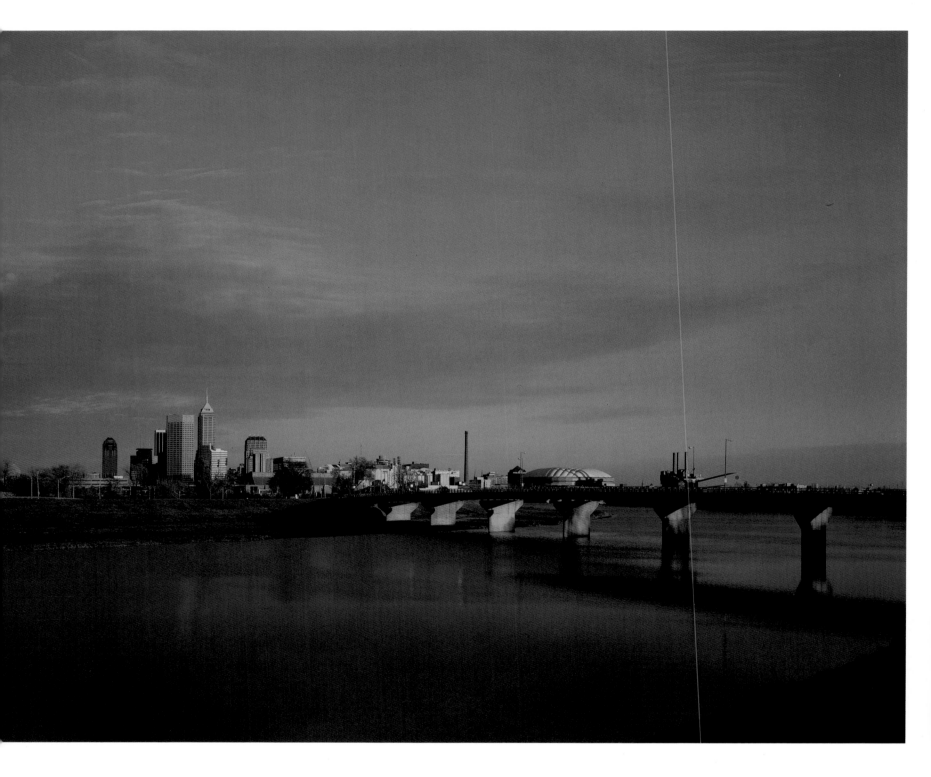

The uninitiated might get the impression that Indianapolis is on a navigable river in this scene shot from the west bank of the city's major natural waterway, White River. But any hope of cooperation by the river was dashed only a few years after the city was created. Robert Hanna's steamboat, loaded with cargo, ran aground in 1831 near the old Washington Street ferry landing. After six weeks the water level rose enough to free the vessel, and it made a hasty departure. Neither it nor any other boat of substantial size has attempted the feat since then. That's the New York Street bridge, carrying one-way automobile traffic.

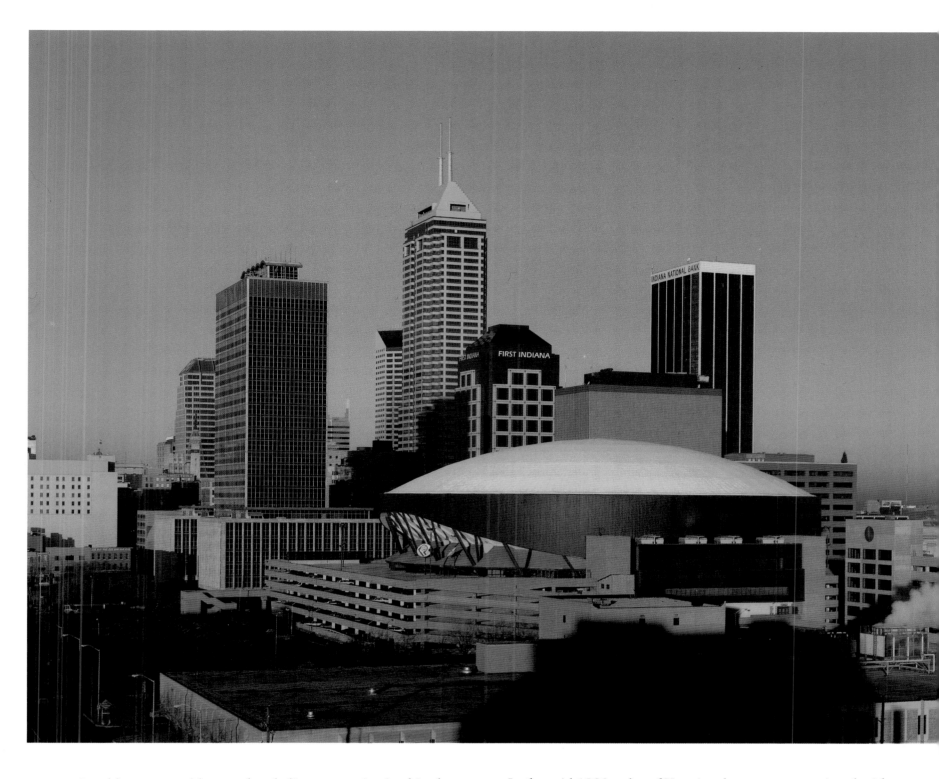

A golden cast emblazons the skyline at sunrise in this shot looking west. Market Square Arena in the foreground looks like a giant television dish or perhaps a ship from outer space about to be launched skyward. Playing prominent yet supporting roles are (left to right) the City-County Building and three of the city's bank headquarters: Bank One, First Indiana, and Indiana National. Only INB and Market Square were there before the late 1980s.

In the mid-1980s a lot of Hoosiers became reacquainted with downtown Indianapolis on Sunday afternoons when the Hoosier Dome (overleaf) opened to provide some 60,000 seats for viewing the city's new professional football franchise in action. The Colts had their good and their bad days in the Dome, but the economic lift has been a constant winner for the city.

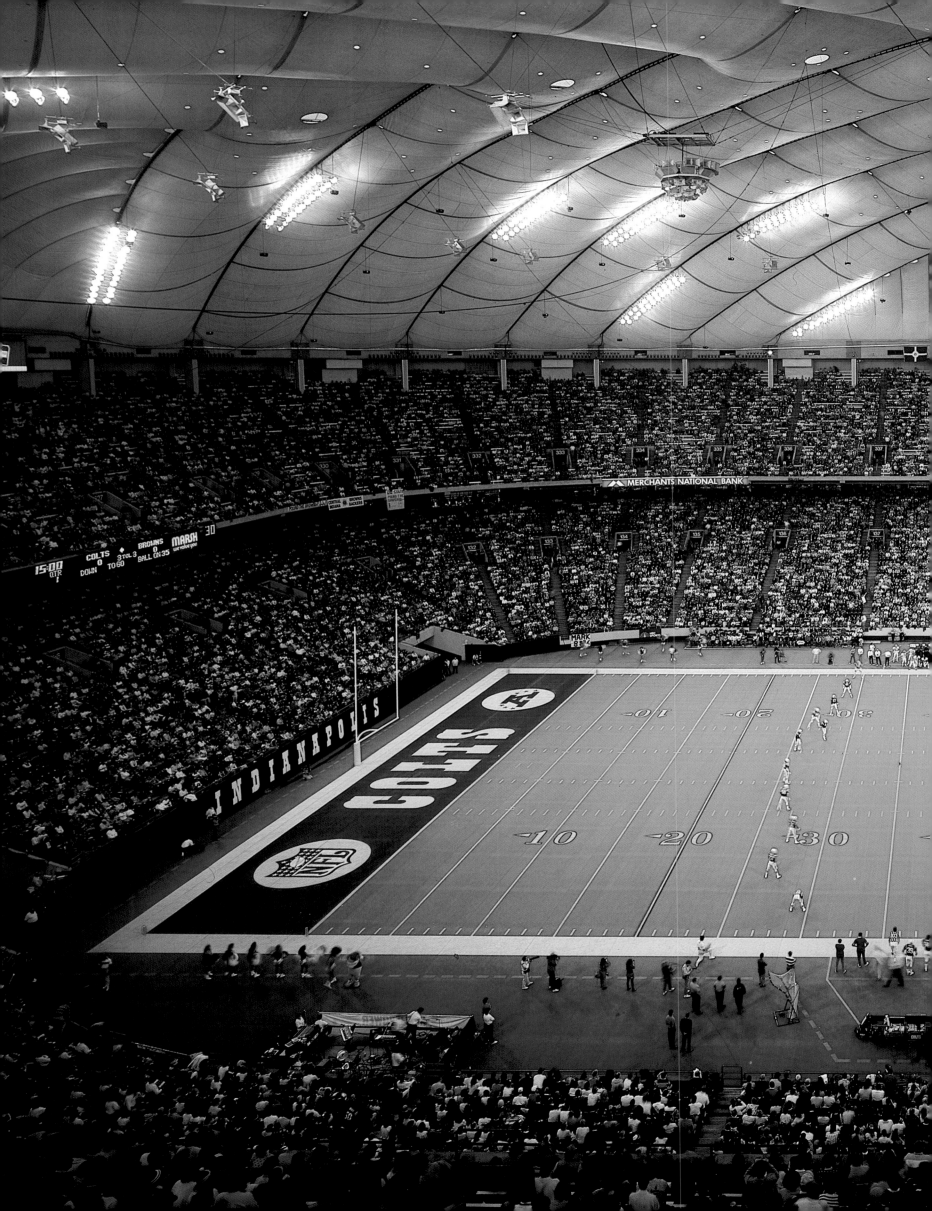

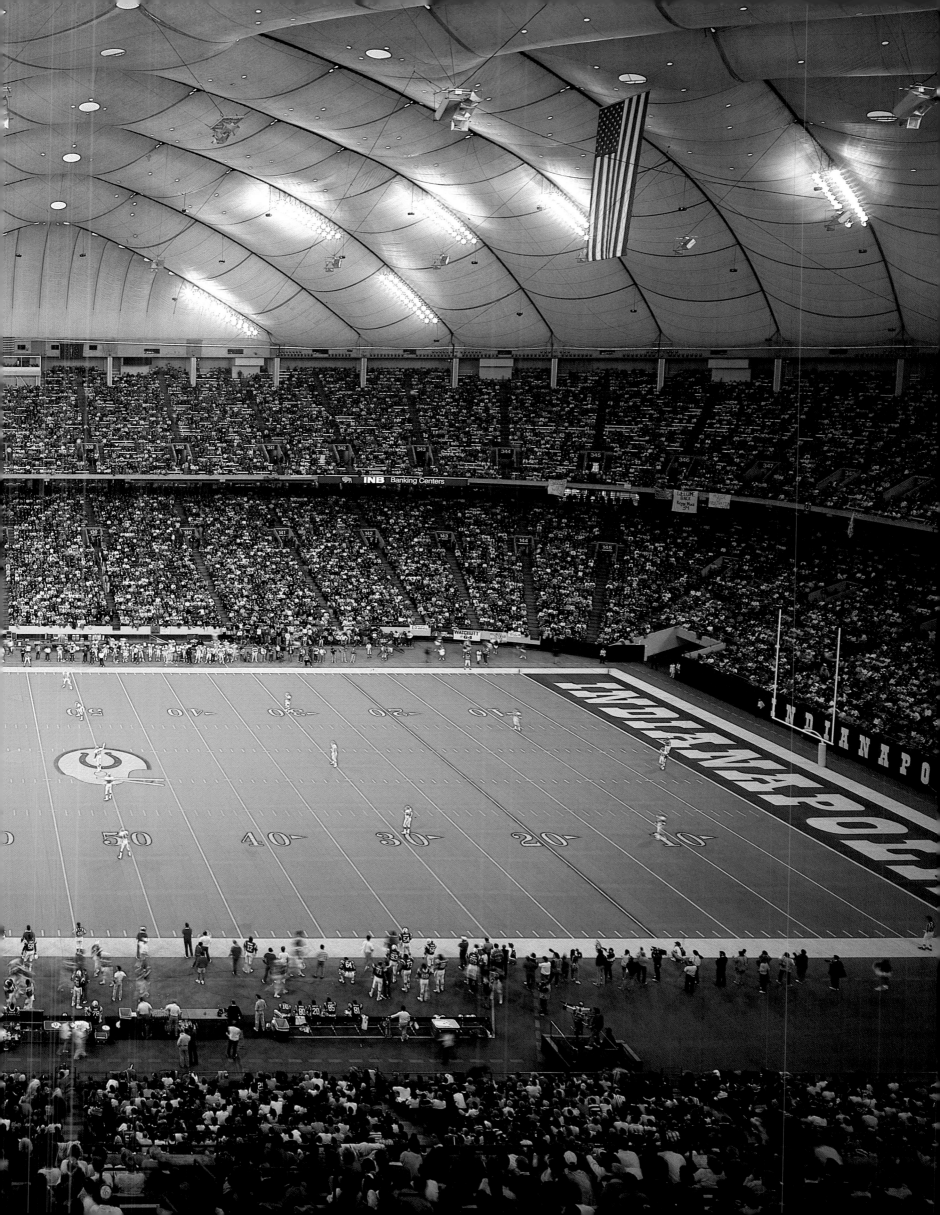

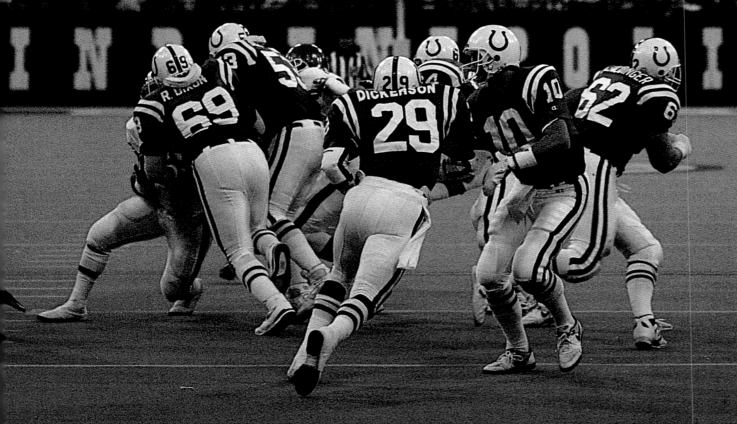

New office buildings were emerging thick and fast in the downtown area in the 1980s. Capital Center occupies the east side of North Illinois between New York and Ohio Streets. The sun adds some effective touches as it shines down from the west. To the extreme right is the shiny Indiana Bell building.

Since 1832 a City Market (overleaf) has operated at its present site, Alabama and Market Streets, east of Monument Circle. It was renovated most recently in 1977. The market is a place of friendliness and character, freely supplied by vendors whose stands frequently go back at least one generation, and in some instances several.

Running back Eric Dickerson brought fresh life to the Indianapolis Colts and sparked renewed enthusiasm for the franchise when he joined the team in 1987. Though Dickerson proved to be a center of controversy, he often won the plaudits of fans by getting the football into scoring position or dashing across the line for a touchdown. At left, Dickerson (no. 29), with Jack Trudeau at quarterback, finds a hole for some yardage.

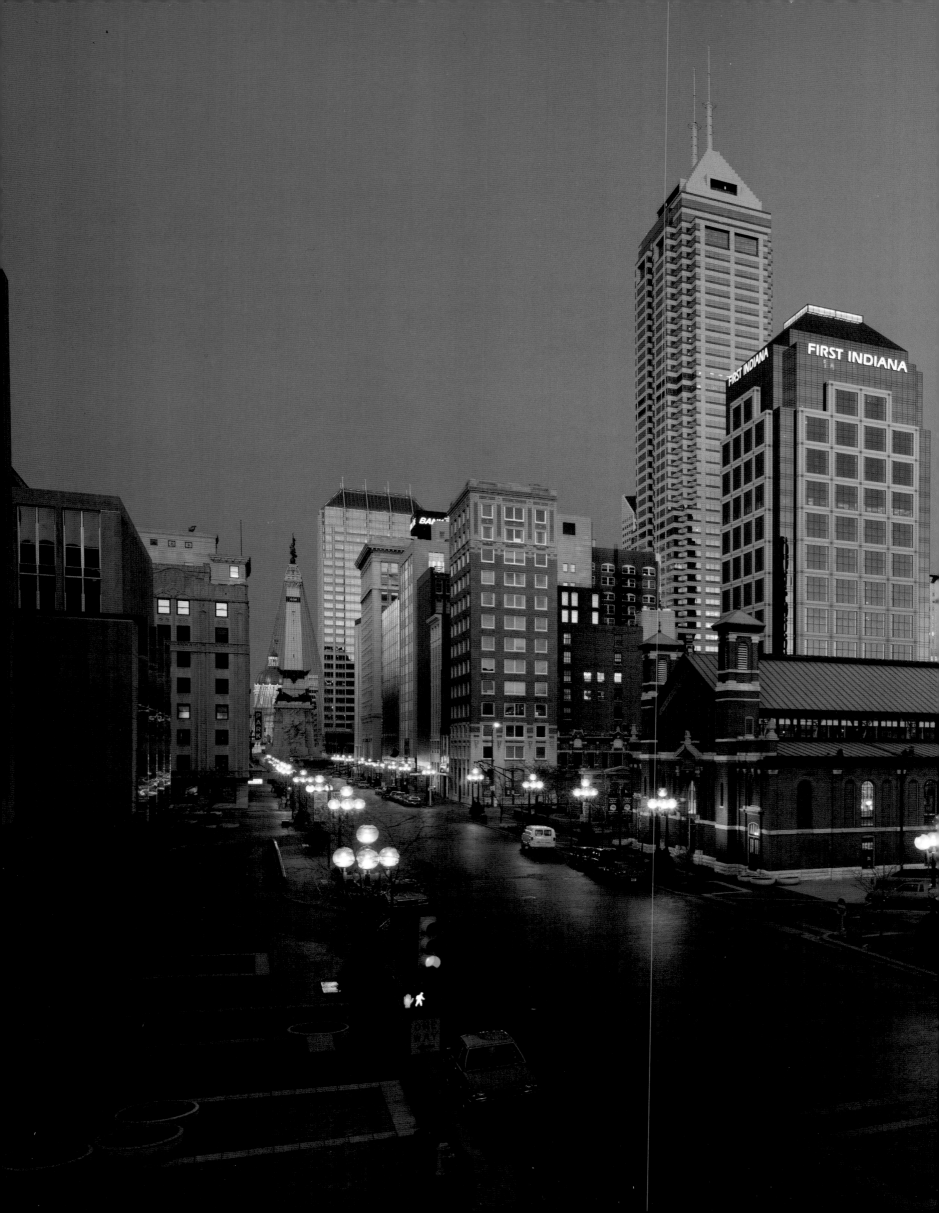

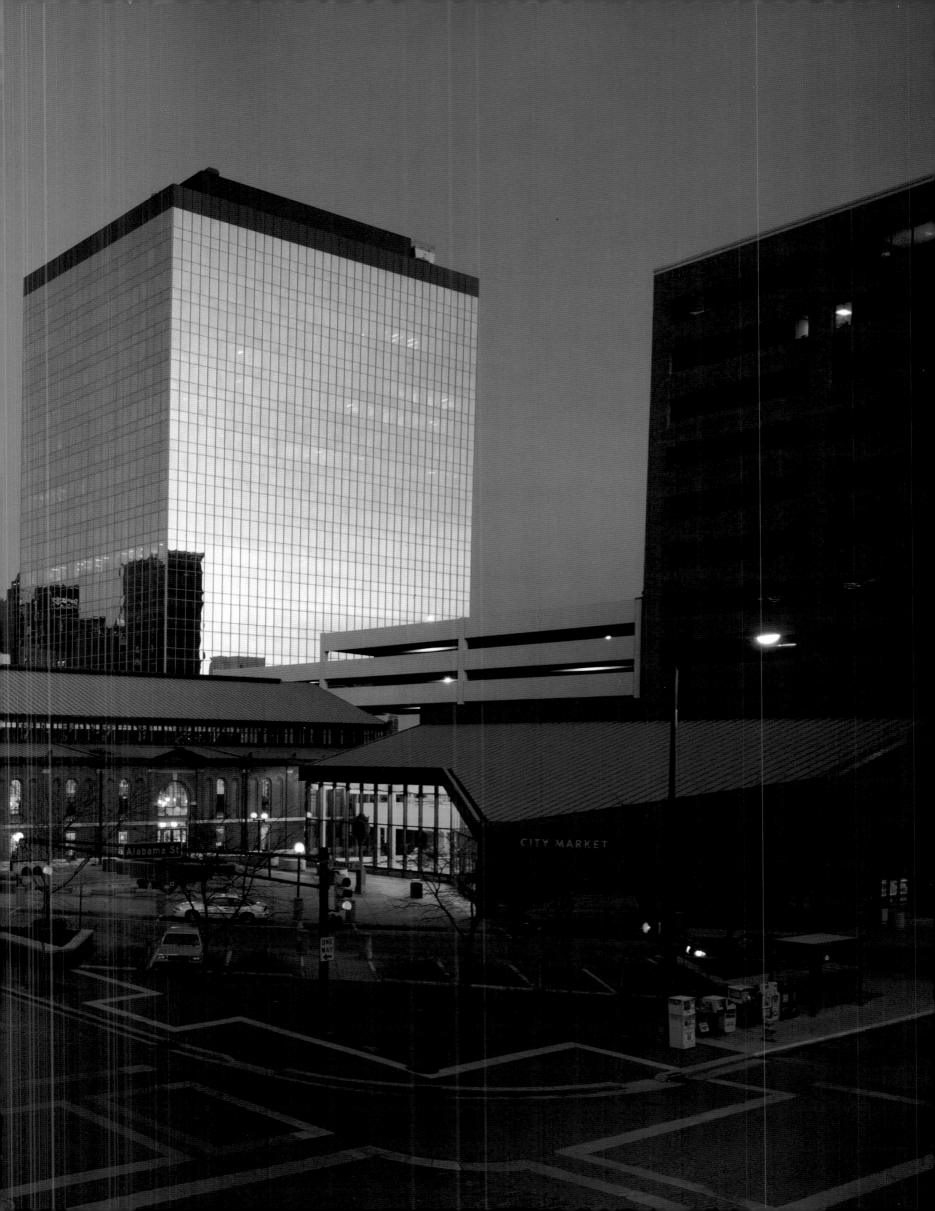

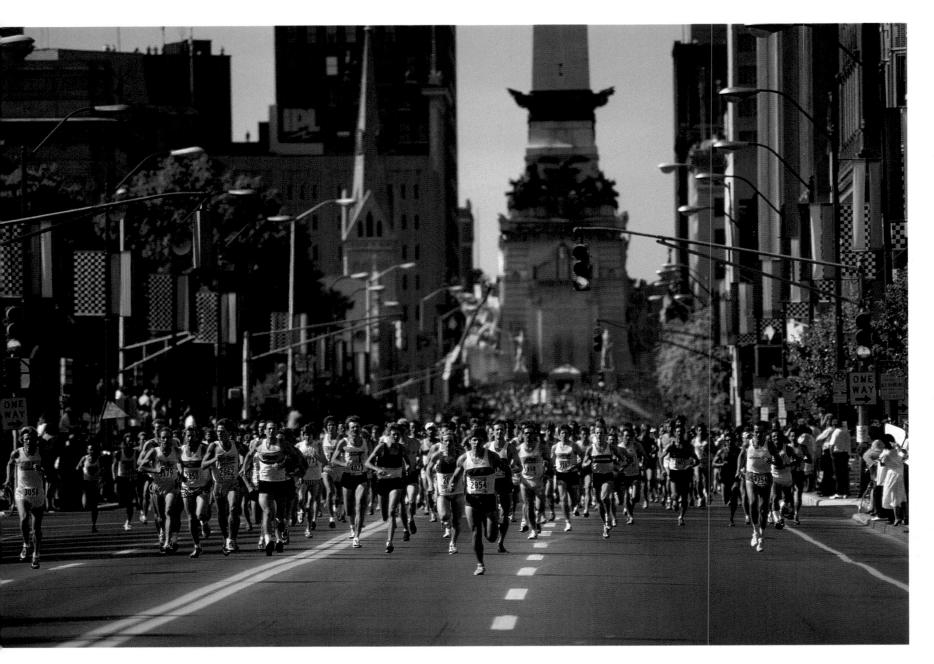

Each May, on the Friday before the 500-mile race, more and more people sign up for a do-it-yourself tour of the city. The only requirement is that they must walk or run the 13.1-mile route. The traditional starting point in what has become a highly popular mini-marathon is on Meridian Street, just north of Monument Circle. The finish, of course, is at the starting line of the Indianapolis Motor Speedway track.

While the city has chosen to restore some old downtown structures, it has by no means shied away from contemporary architecture. The audacious example at right is the Market Square Center office building, sometimes called the gold building for obvious reasons. It is at Alabama and Market Streets. This shot was taken late on an afternoon when sunlight was engaged in an active exchange with the building.

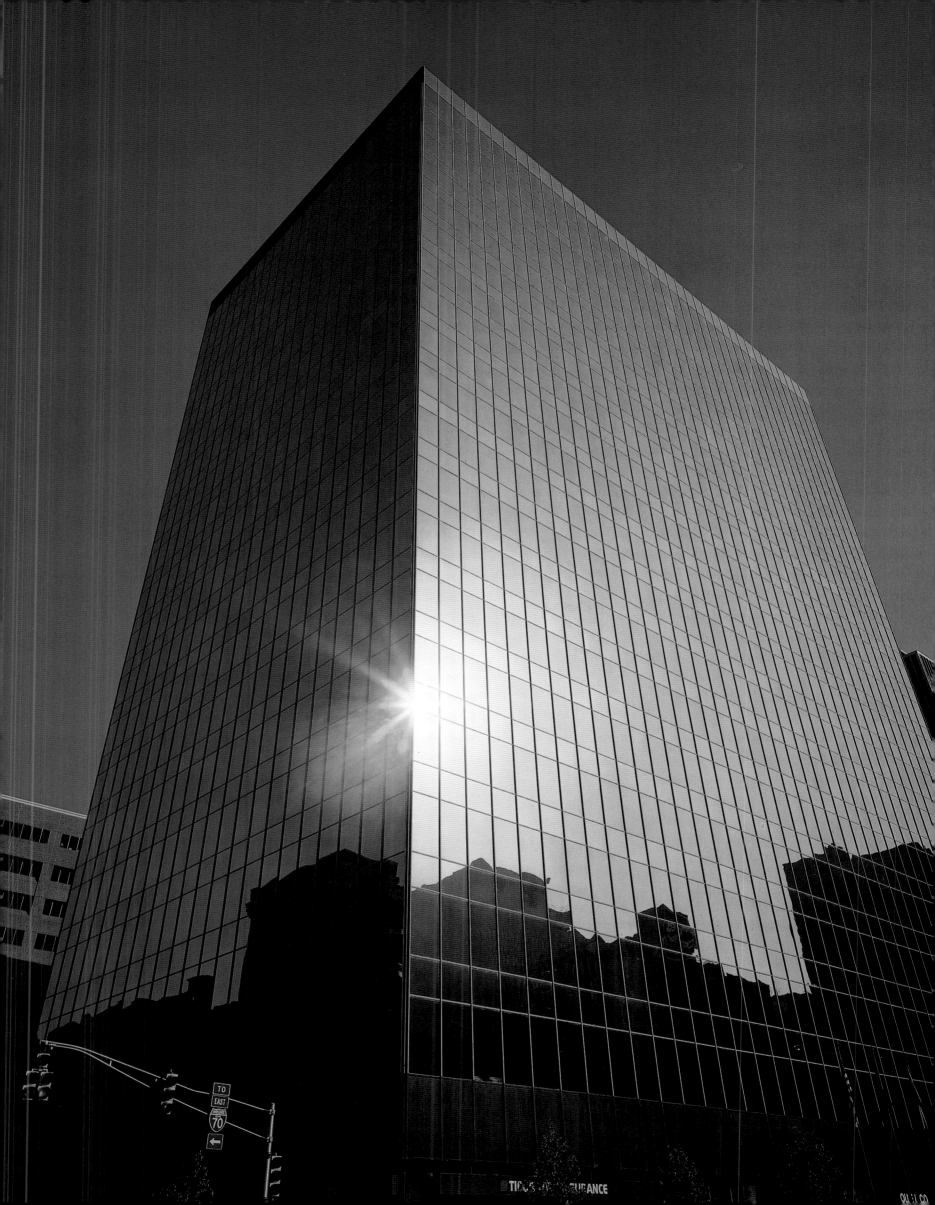

Four-term Mayor William F. Hudnut has presided over much of the modernization of Indianapolis.

At first glance this picture may appear to be a fugitive from someone's attic or old file cabinet going back to World War II days. Actually the camera action took place during a flyover of the city by the Red Baron Aerobatic Team. The team's pilots were performing at an air show sponsored by the Indiana wing of the Confederate Air Force, an organization dedicated to restoring World War II aircraft. Biplanes such as these were used for training purposes. Photographer Jones was aboard one of them as the group headed west above Interstate 70 on the eastside.

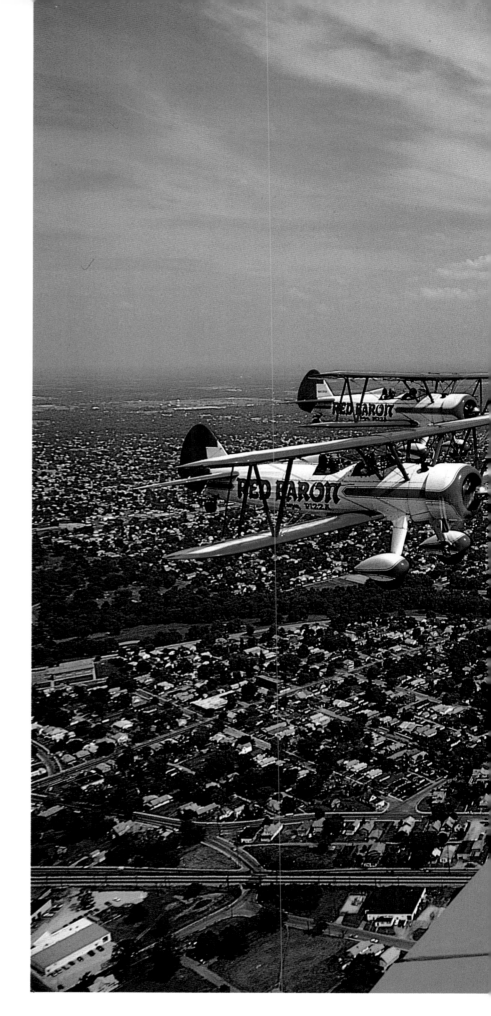

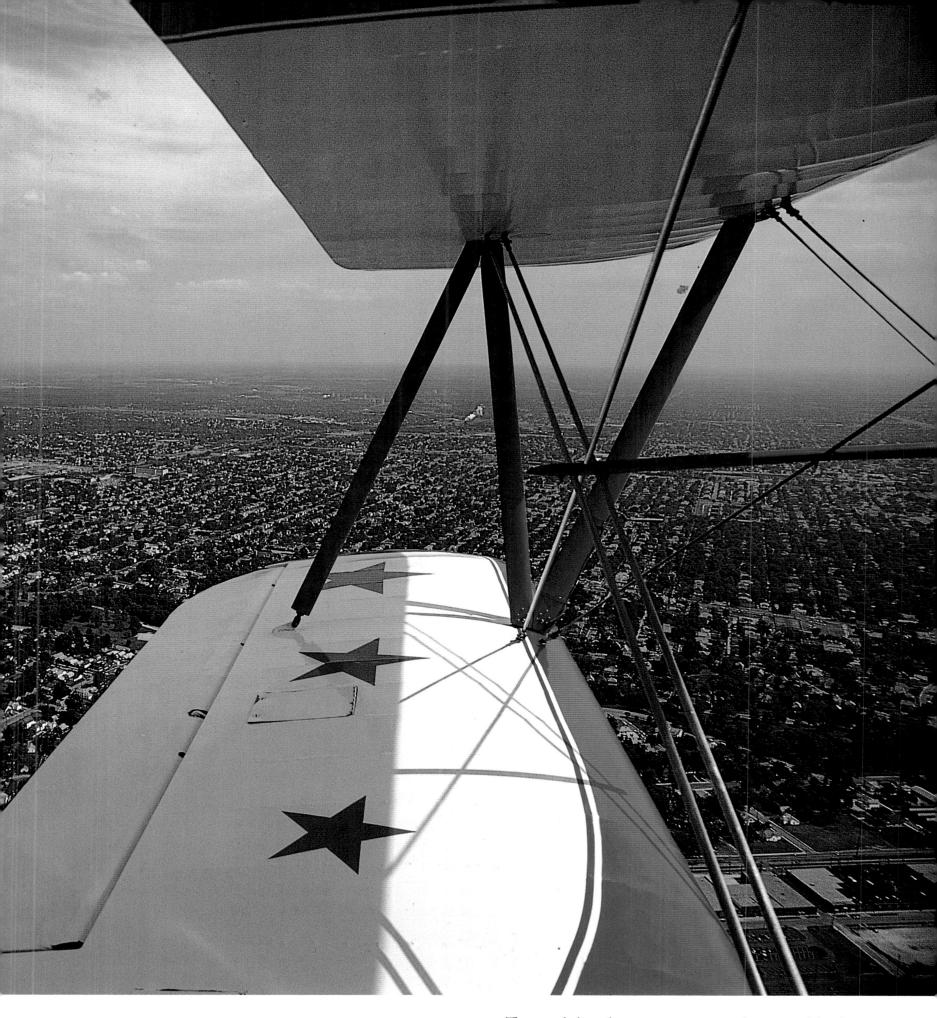

Thousands line downtown streets on foot or on bleachers to see the annual 500 Festival Parade. High school bands, both local and from some distance, are among the participants. They all know full well that when they reach the checkered area (overleaf) they are under the scrutiny not only of the parade judges but also of television cameras that transmit the proceedings to a specially arranged network of stations throughout the country.

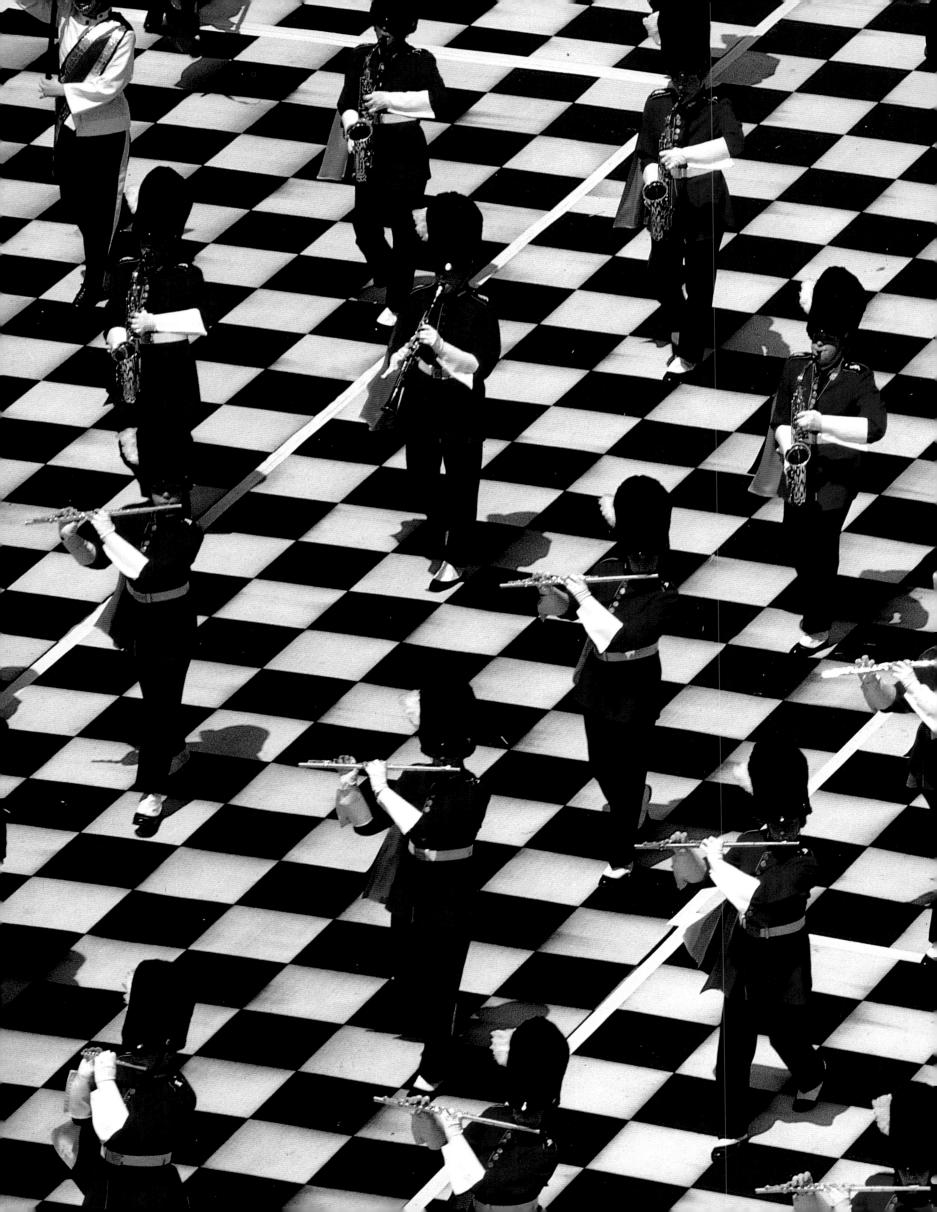

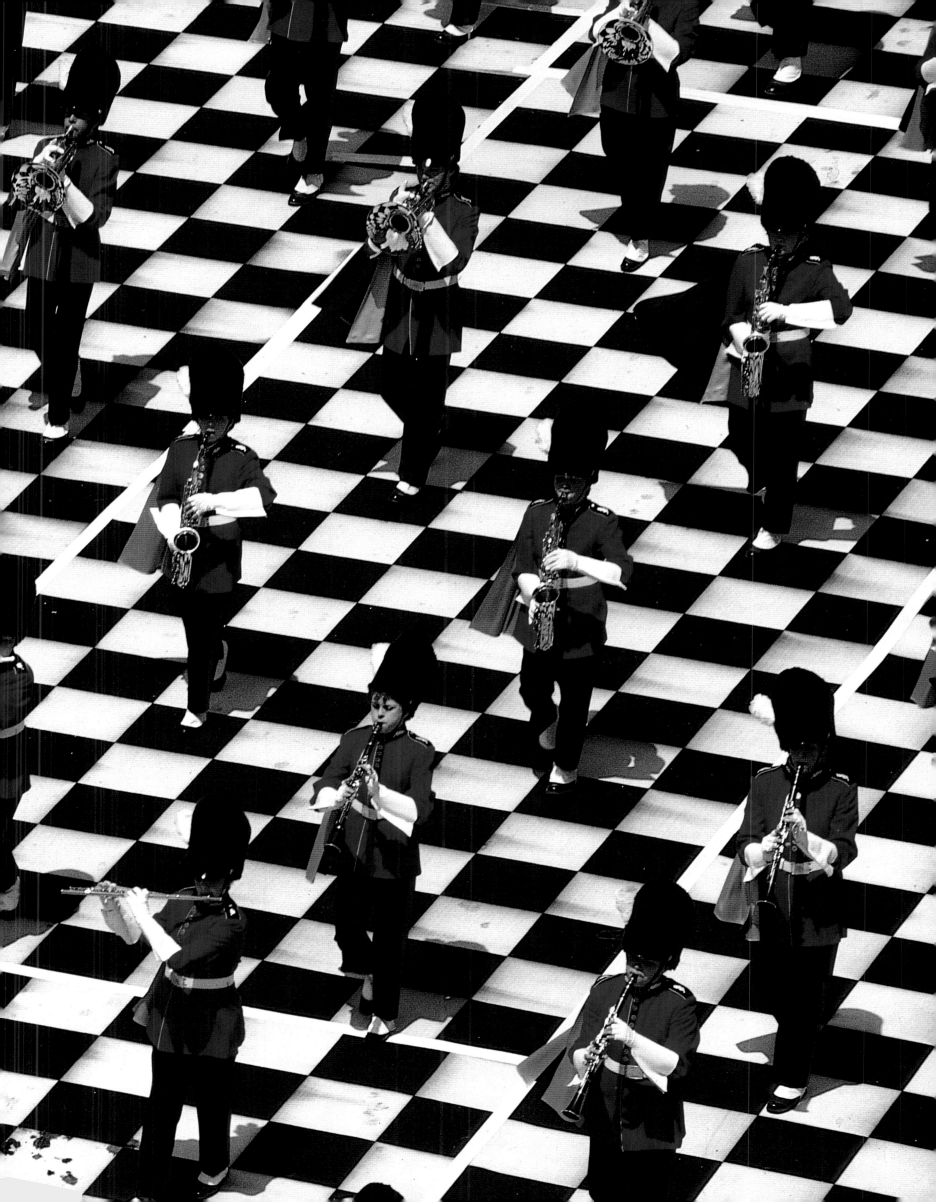

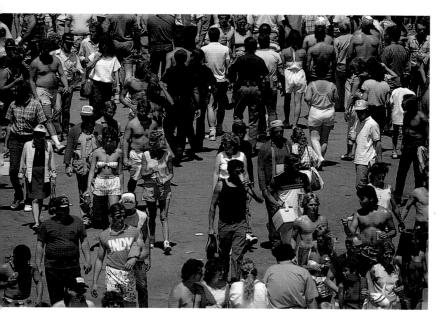

Once in a while it rains, but most years in the long history of the 500-mile race the weather has cooperated. That certainly was the case in 1989. From the look of the fans at top left as they head for their seats just prior to the colorful opening ceremonies, they all are convinced that the weather will present no problem.

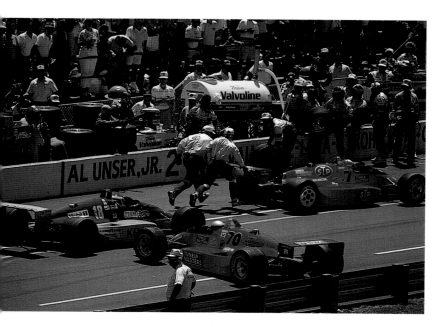

Pit action sometimes gets as interesting as the proceedings out on the track. At lower left, John Andretti (car no. 70) has just spun around, while the crew for Tom Sneva (car no. 7) gets him rolling back to the track and Bobby Rahal (car no. 18) looks on. The action provided only a moment of suspense. No problems followed, though none of the three finished well in that race. Sneva and Rahal are former winners of the big event.

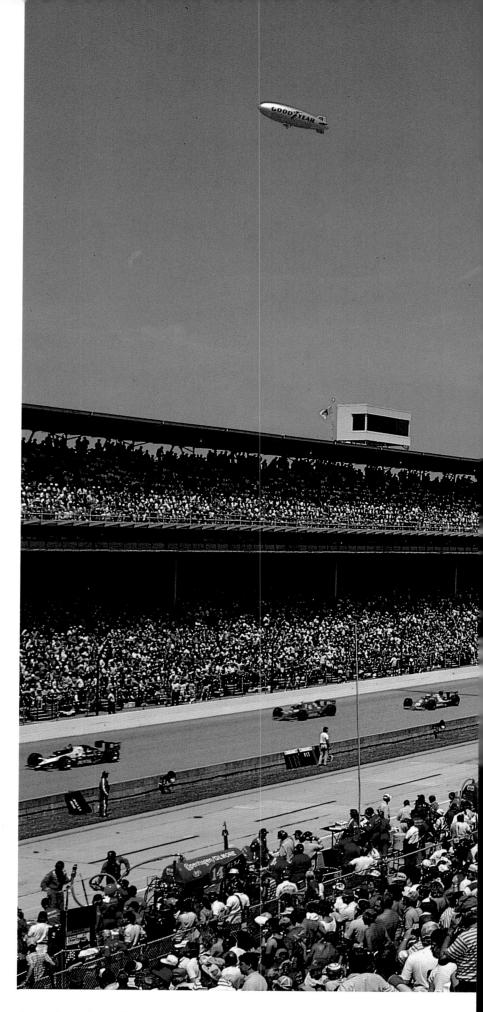

Some Speedway fans get a lump in the throat when they view the action down the main straightaway on race day.

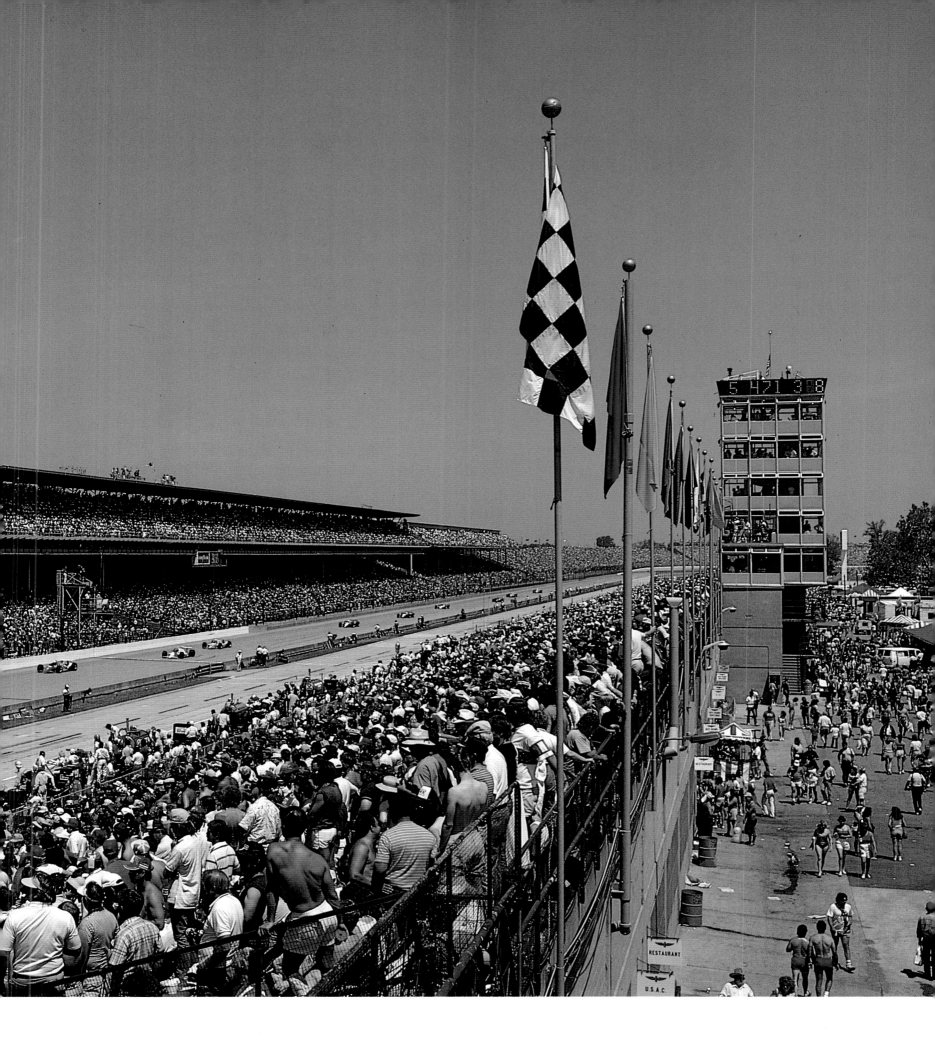

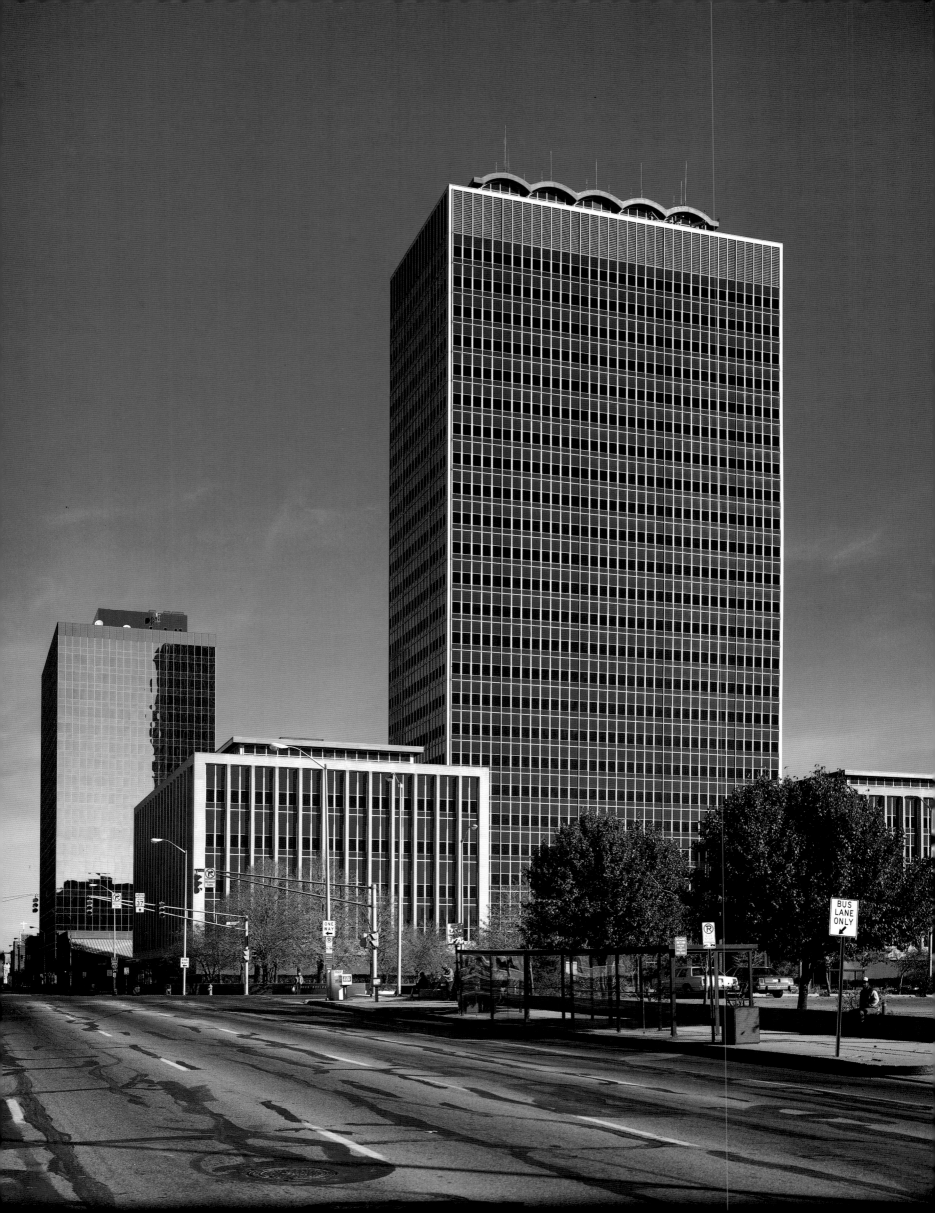

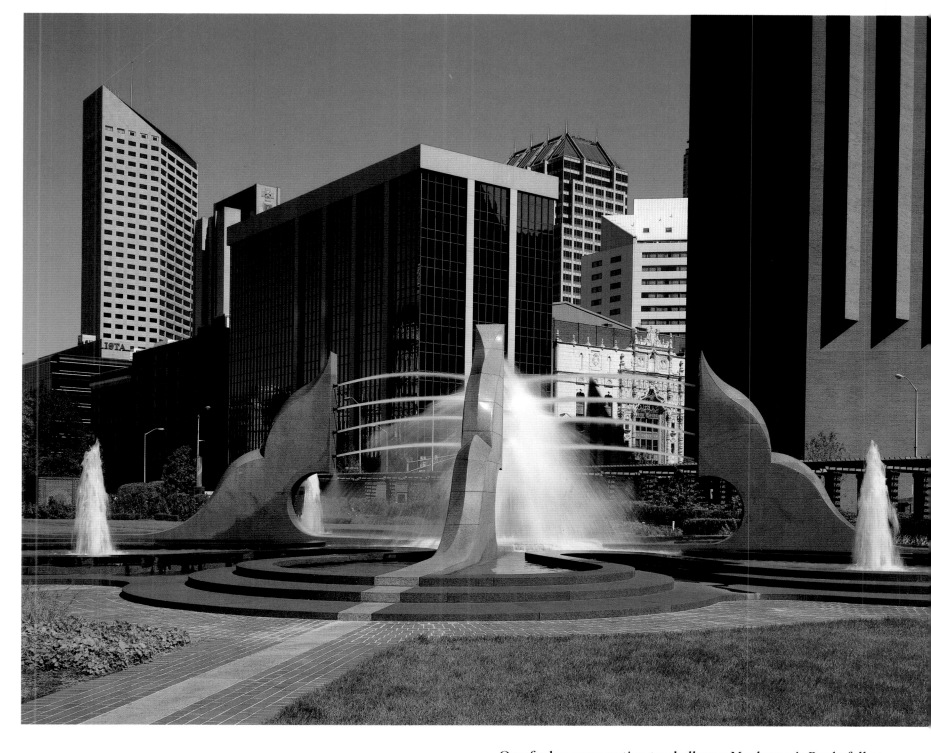

One finds a perspective to challenge Manhattan's Rockefeller Plaza in the view above of downtown Indianapolis. It's looking northeast from the fountain in Convention Center Plaza, in front of the new Westin Hotel. The plaza stretches from the Convention Center to the State Capitol. Straight ahead, beyond the fountain, is the One North Capitol building and the dazzling facade of the Indiana Theatre, home of the Indiana Repertory Theatre.

Indianapolis's modern-day skyline really got going when the 22-million-dollar, 28-story City-County Building went up in the early 1960s (left). Funding came exclusively from local revenue bonds; citizens' sentiments at that time were firmly against accepting federal money. The building, which replaced a decaying Marion County Courthouse, provides office space for both city and county government workers.

19

The old, the new, and the city's love of physical fitness are all represented in the nighttime skyline scene above. The brand new Bank One Center Tower is the tallest building, while the complex on the lower right is considered to be the city's oldest continuous business operation. A corn grist mill was operating there in 1821, the forerunner of the Acme-Evans flour business, which has been there since 1902. Just left of that old facility is the Sports Center for tennis. The Indiana University Track and Field Stadium and the I.U. Natatorium are nearby. Extending across the scene at bottom is the National Institute for Fitness and Sport.

Christmas was just a little more festive in 1989 because it was the first time in three years that the Indiana Soldiers and Sailors Monument had been turned into a Christmas tree. Major restoration of the monument's exterior had forced it into darkness; restoration continued but was confined to the interior. For many, the restoration was already complete enough, and thousands gathered for the occasion. After all, the world's largest Christmas tree was back.

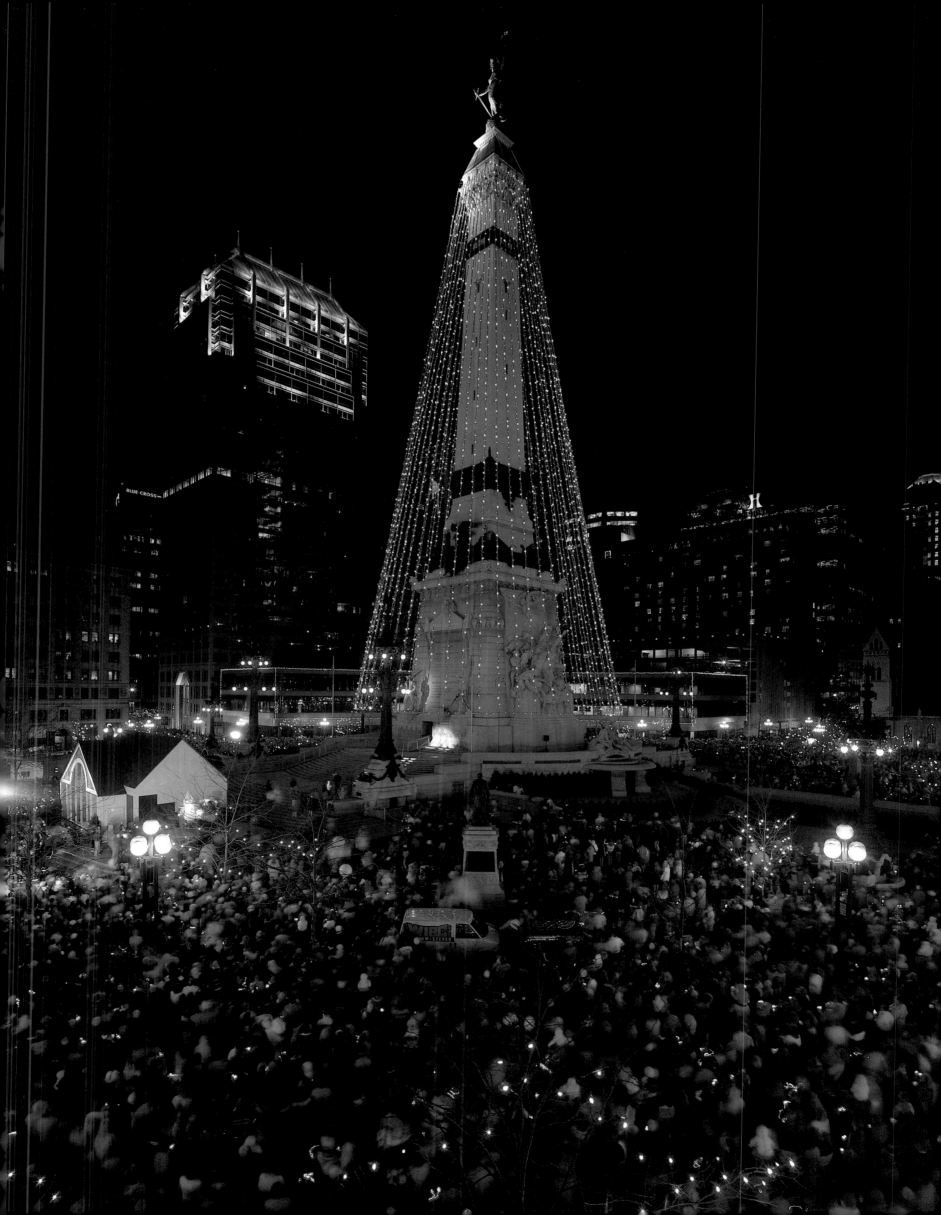

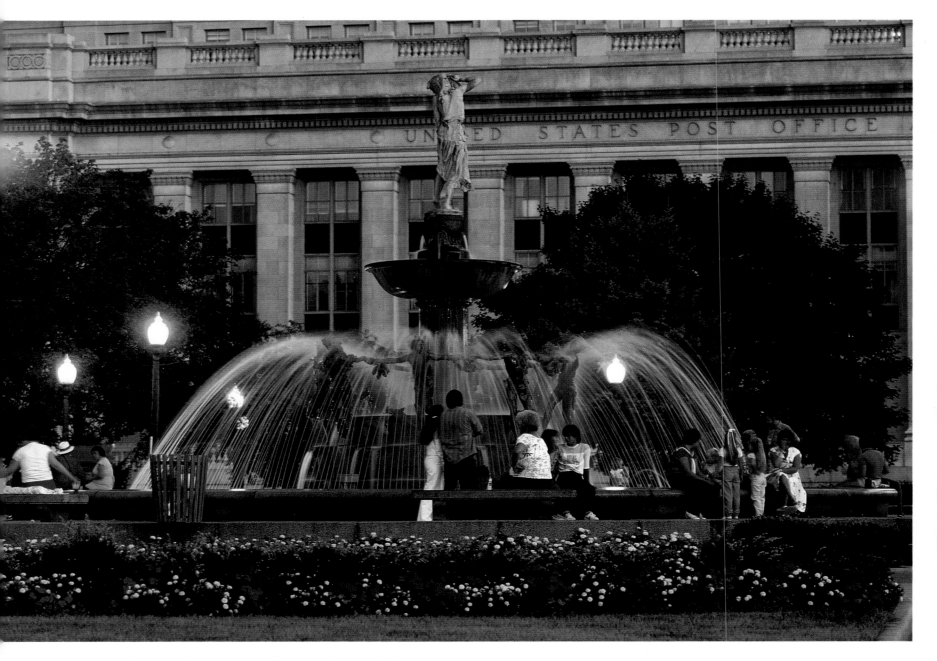

A glance at the late afternoon attendance in University Square downtown on any work day will reveal just how mild the temperature is. The Memorial Fountain (above) is a favorite gathering place for workers who wish to brown bag it or just relax and visit. To the south, beyond the fountain, is the Italian Renaissance United States Courthouse and Post Office, now known as the Old Federal Building.

Indianapolis itself was rather youthful (only 35 years old) when Butler University was added to the city's landscape in 1855. Since the late 1920s Butler's home has been the former Fairview Park on the northside. Three of the university's 4,100 undergraduate, graduate, and part-time students were heading for class when this photograph was taken.

The courtyard plaza south of Washington Street provides an impressive setting (overleaf) for the dignified State Capitol that has served Indiana since the 1880s. A major restoration of the statehouse in the late 1980s assured Hoosiers that it will be around for a long time to come, though it manages to house only a portion of the state government's personnel.

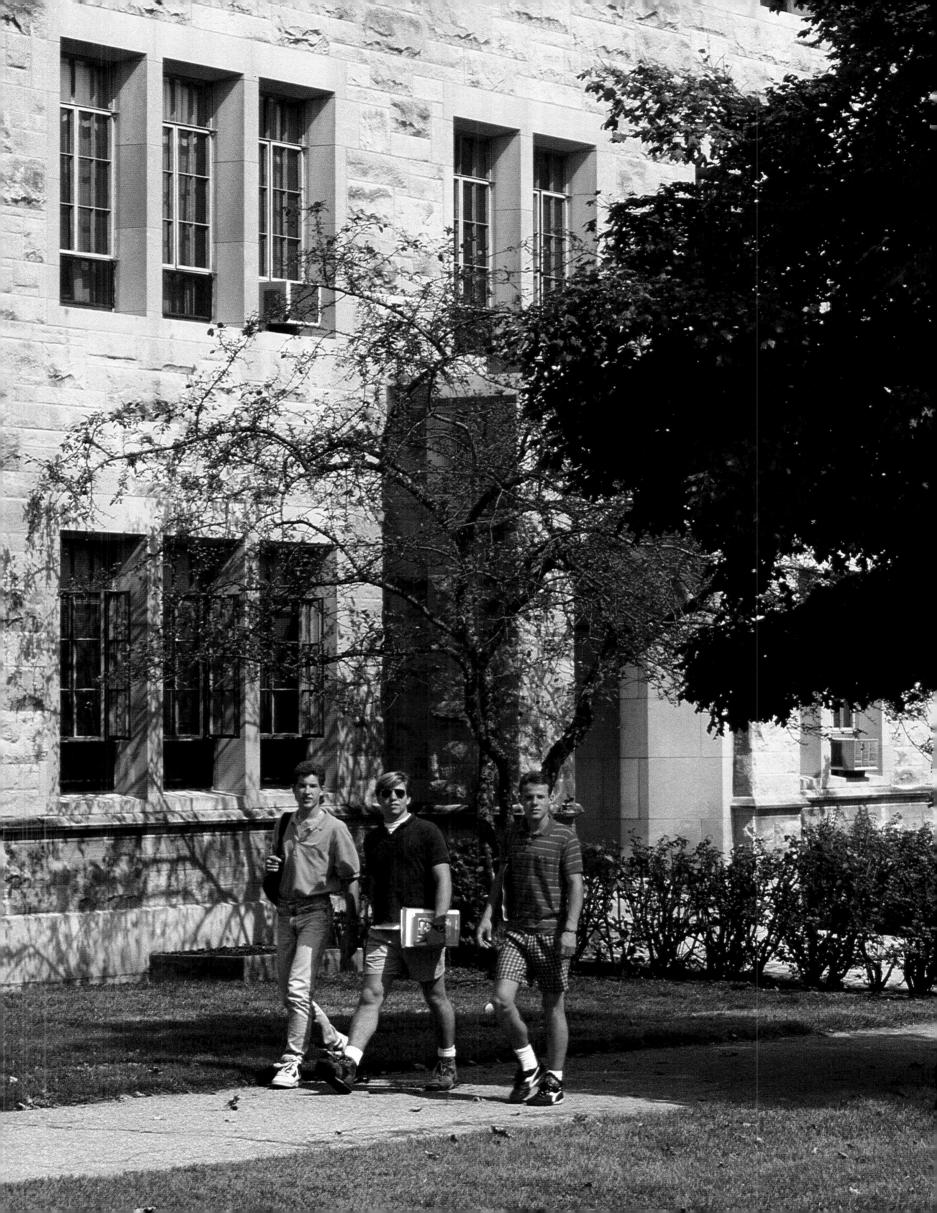

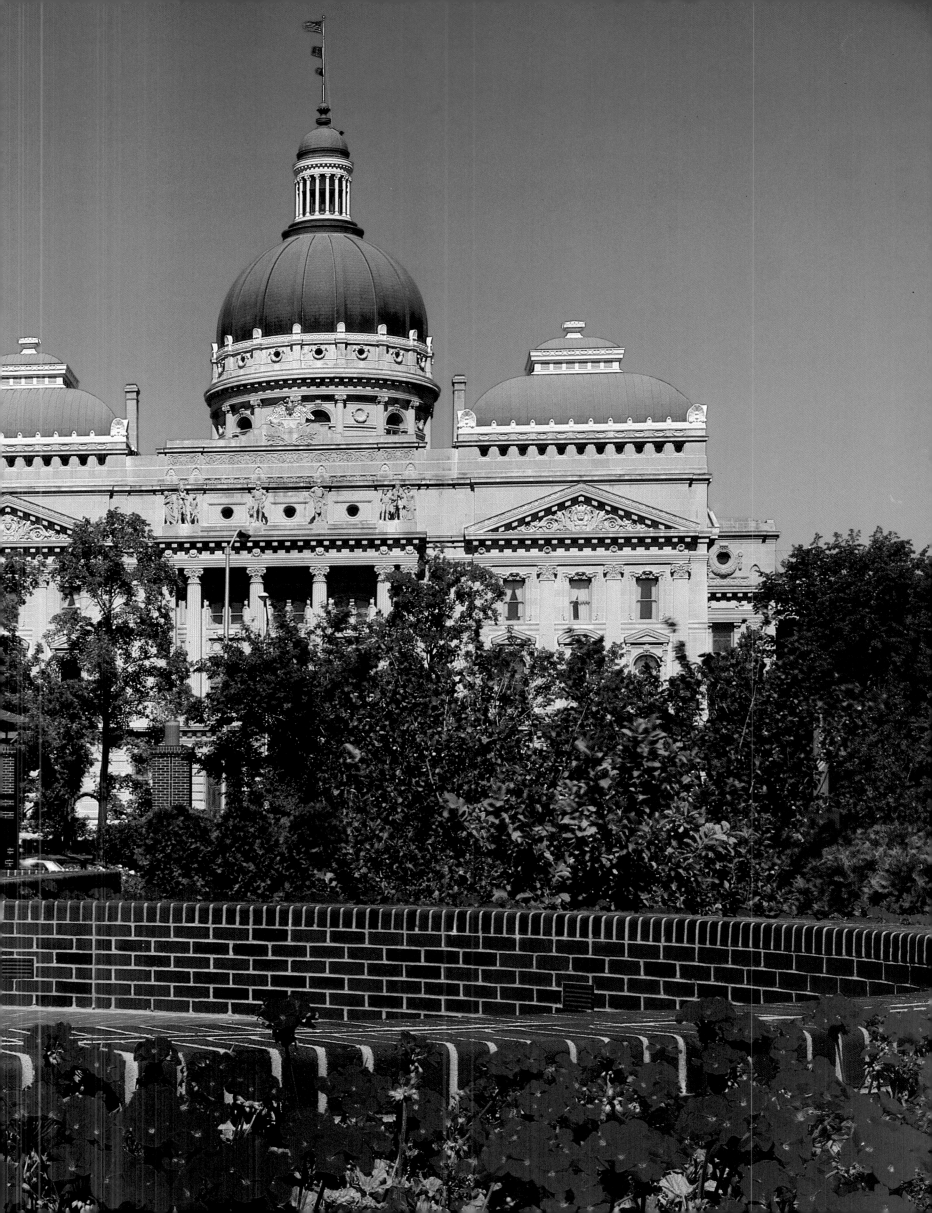

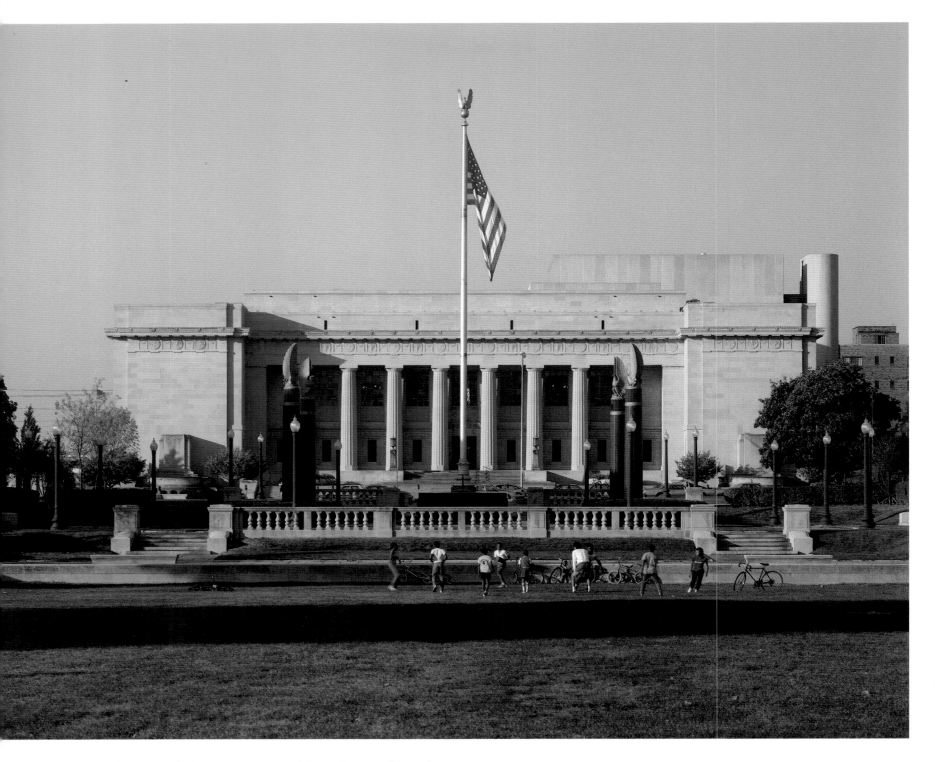

In front of Cenotaph Square, a memorial to the youths and others lost by the state and city to World War I, youngsters of a few generations later compete in some touch football (above). Behind the memorial is the headquarters of the countywide library system. The Greek Doric–style Central Library, built just before the country entered World War I, underwent extensive interior renovations in the 1980s.

Banners and animal heads adorn the schlossgarten, one of several fascinating rooms at the Athenaeum, the city's German cultural center that dates back to the late nineteenth century. The schlossgarten is located just off the rathskeller, where lunch is served daily.

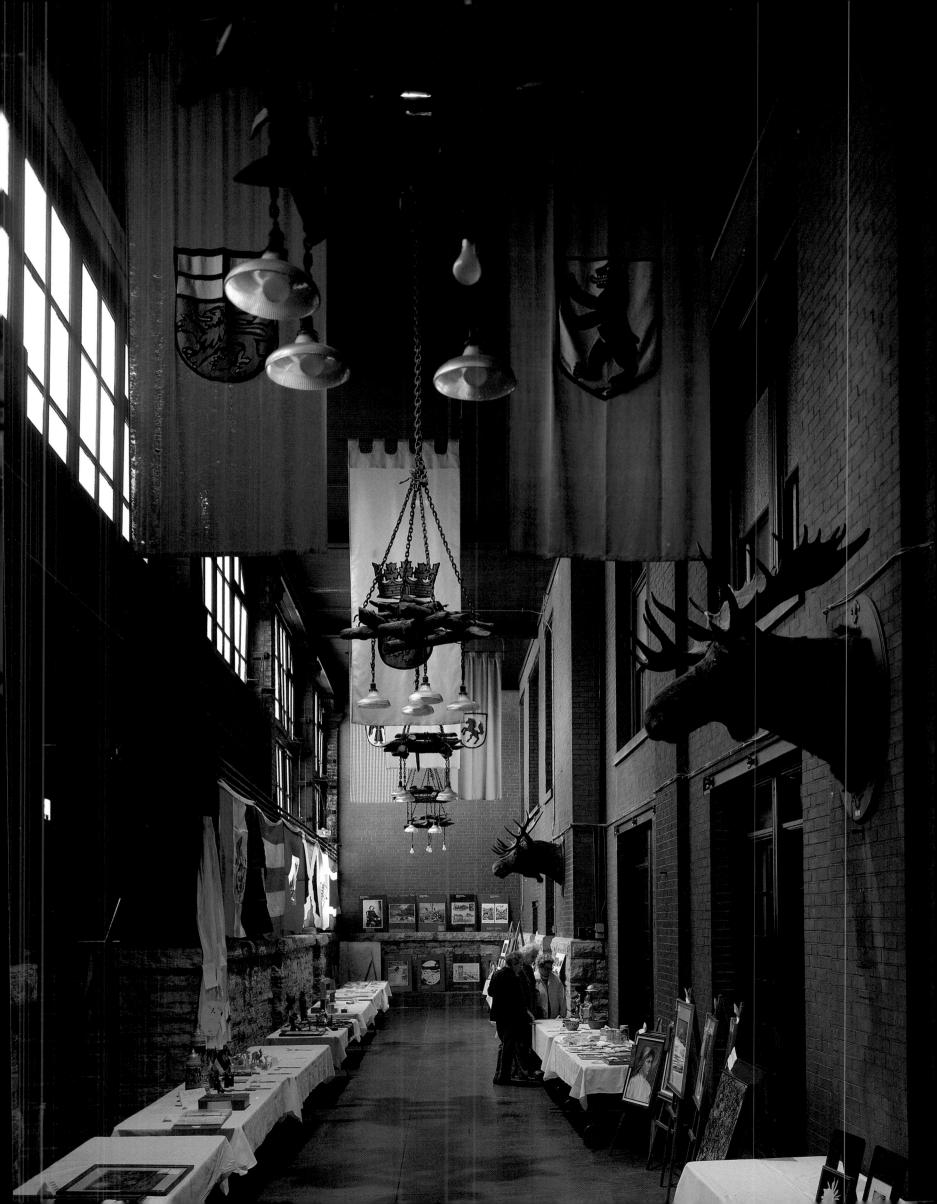

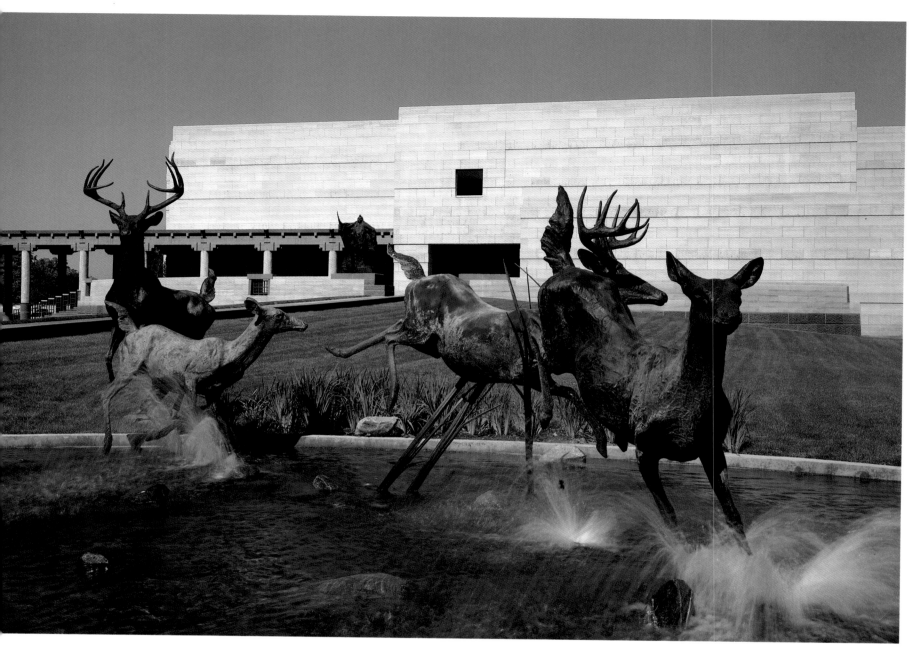

Five frisky deer models dash through the water to add a charming touch to one of the city's newest cultural centers. The fountain is on the grounds of the Eiteljorg Museum of the American Indian and Western Art. Considered one of the nation's most complete of its kind, the museum's collection was gathered by business executive Harrison Eiteljorg and is housed at the western edge of downtown in White River State Park.

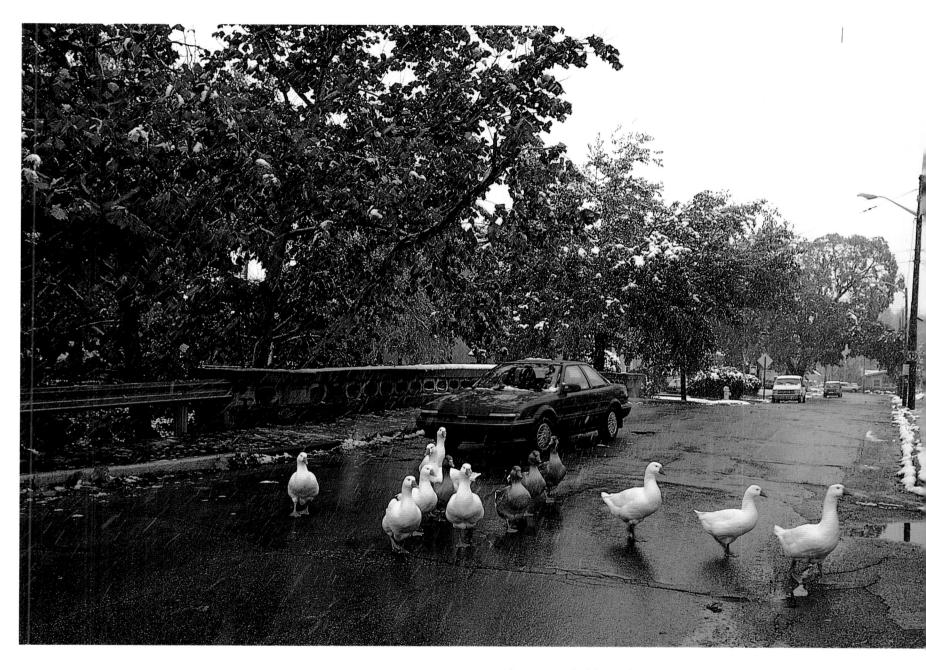

Along Westfield Boulevard, where it parallels the Central Canal near Broad Ripple, automobile traffic sometimes intrudes on a more important segment of the population. These ducks and geese have high visibility and acceptability among the area's residents, so motorists beware!

The curious fellow at left is one of 2,000 faunal residents of the 64-acre Indianapolis Zoo, which opened near downtown in the summer of 1988. The zoo was the first major construction project to be completed for the 270-acre White River State Park.

The poster and statement at right, drawn by a young visitor, clearly states the goal of the Children's Museum of Indianapolis. From the moment one encounters the 55-foot atrium and the world's largest water clock at the museum's entrance, one knows the place is something special. But what else would one expect of the world's largest children's museum? It thrills 1.5 million young curiosity seekers a year.

Marine life—including the seals in the aquarium complex below—is a featured part of the Indianapolis Zoo, at a cost of more than 20 million dollars. The zoo also has an exciting enclosed Whale and Dolphin Pavilion. No tax money went into the facilities.

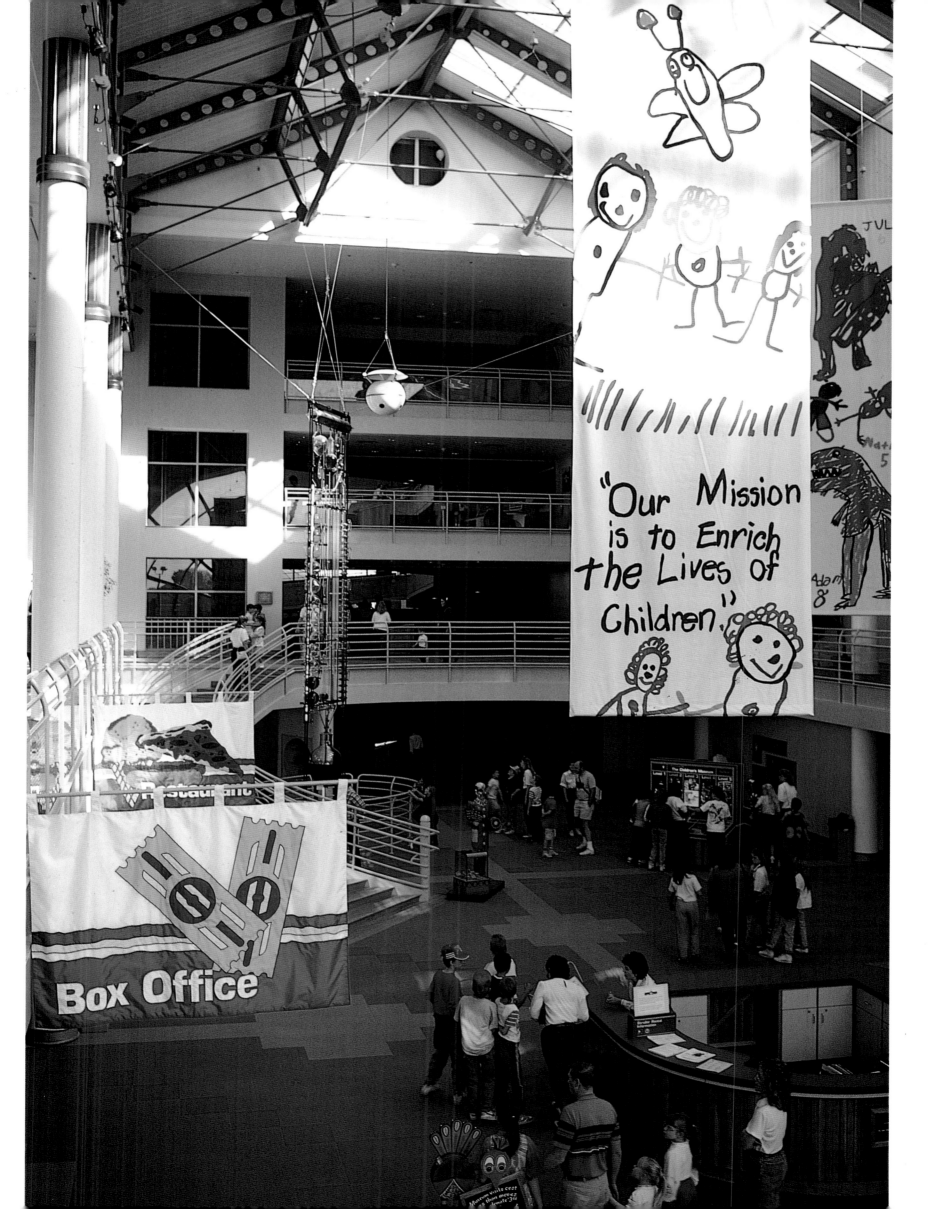

"Our Mission is to Enrich the Lives of Children."

Box Office

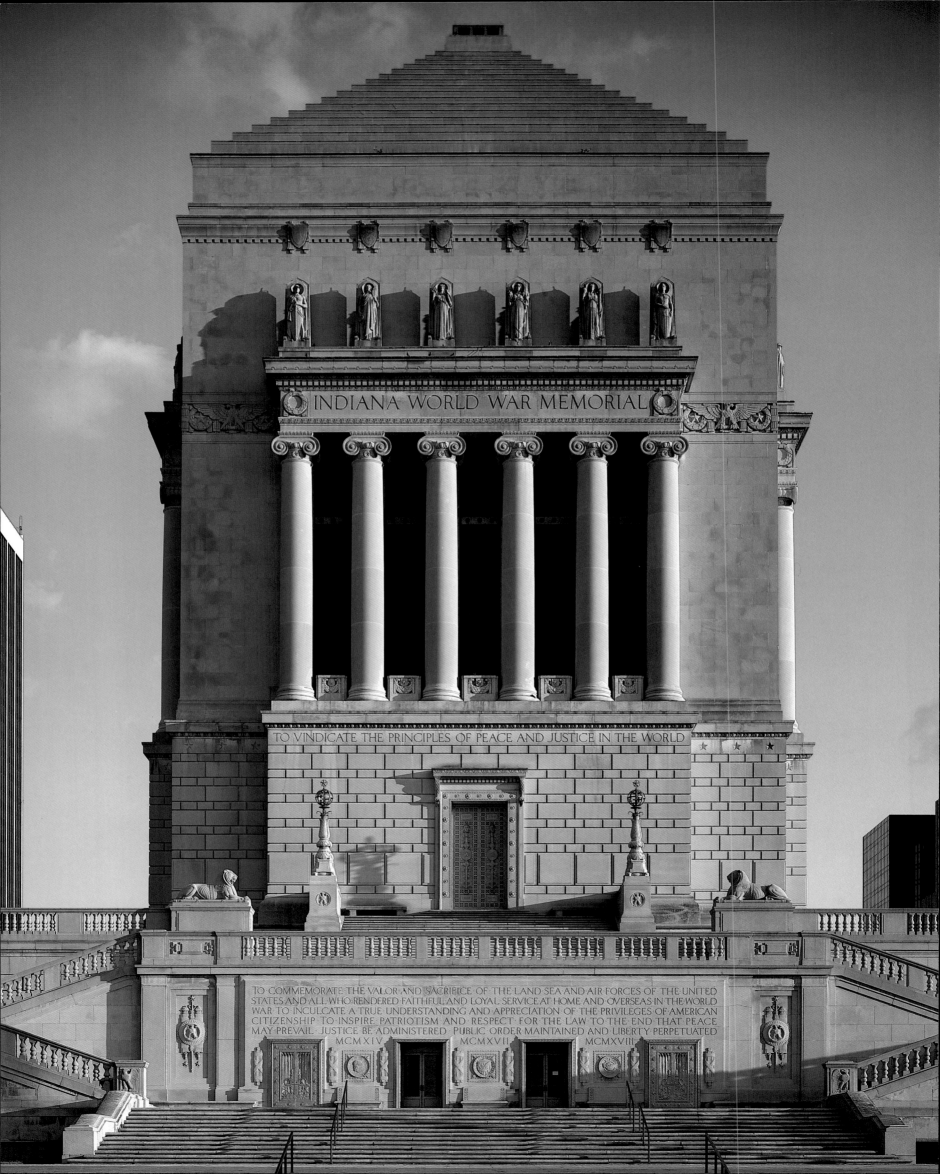

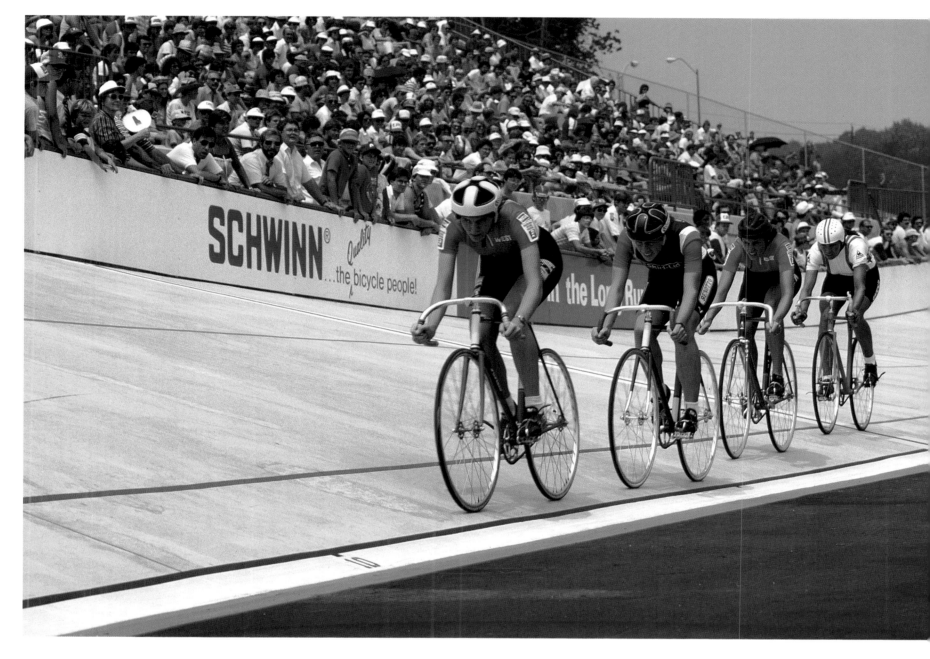

Indianapolis was the site of some major bicycle races in the late nineteenth century, so it is only fitting that it should now be one of the few U.S. cities with a facility capable of handling major bike competitions. One of the country's best competitors was Hoosier Marshall (Major) Taylor, who was the American sprint champion twice and the world title winner in 1899. The Major Taylor Velodrome is at West 38th Street and Cold Spring Road.

The Indiana World War Memorial provides a solemn and dignified atmosphere for military ceremonies throughout the year. Built of Indiana limestone in the late 1920s to honor the state's servicemen who were killed in World War I, it has also come to be the place to honor Hoosiers who made the supreme sacrifice in subsequent wars.

33

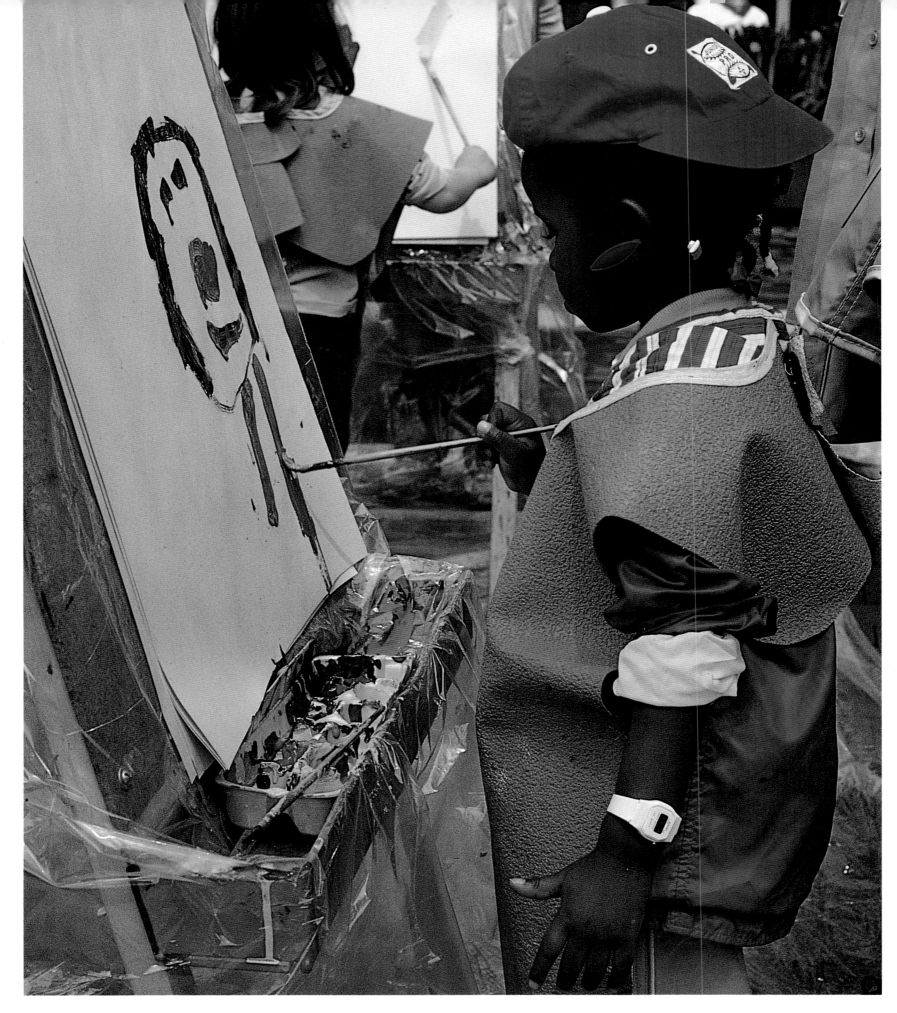

Summertime finds activities many and varied on Monument Circle. This young woman is quite absorbed in expressing her artistic ideas on paper.

Flags from nations that participated in the Pan American Games in Indianapolis in the 1980s add to the regal appearance of Union Station, one of the last of the country's Victorian-era train terminals. Built of brick and limestone in Romanesque style, it opened in the late 1880s, only to fade away as train service declined in the 1960s. But a long struggle saved it, and today it again functions briskly—as a shopping, dining, and hotel facility for fun lovers of all ages.

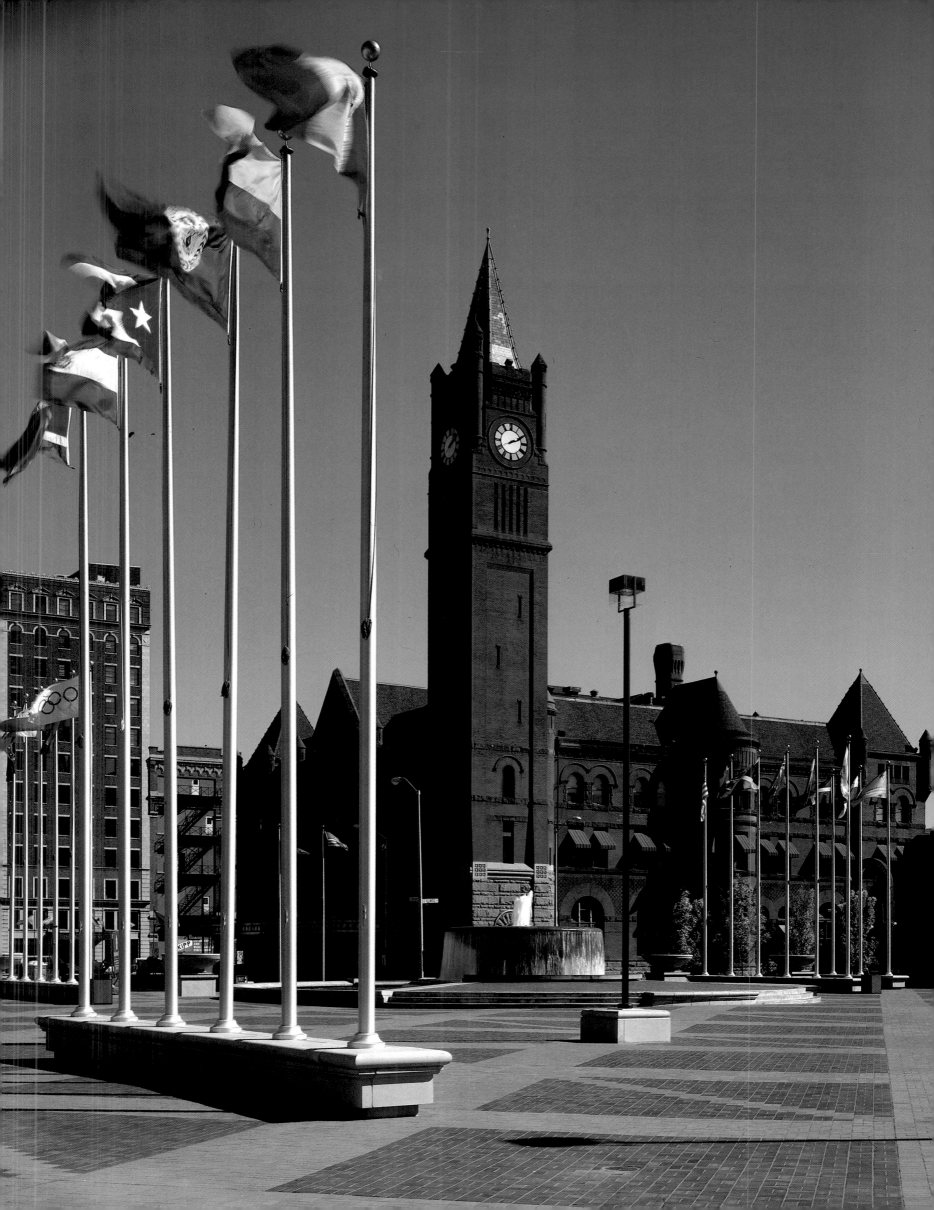

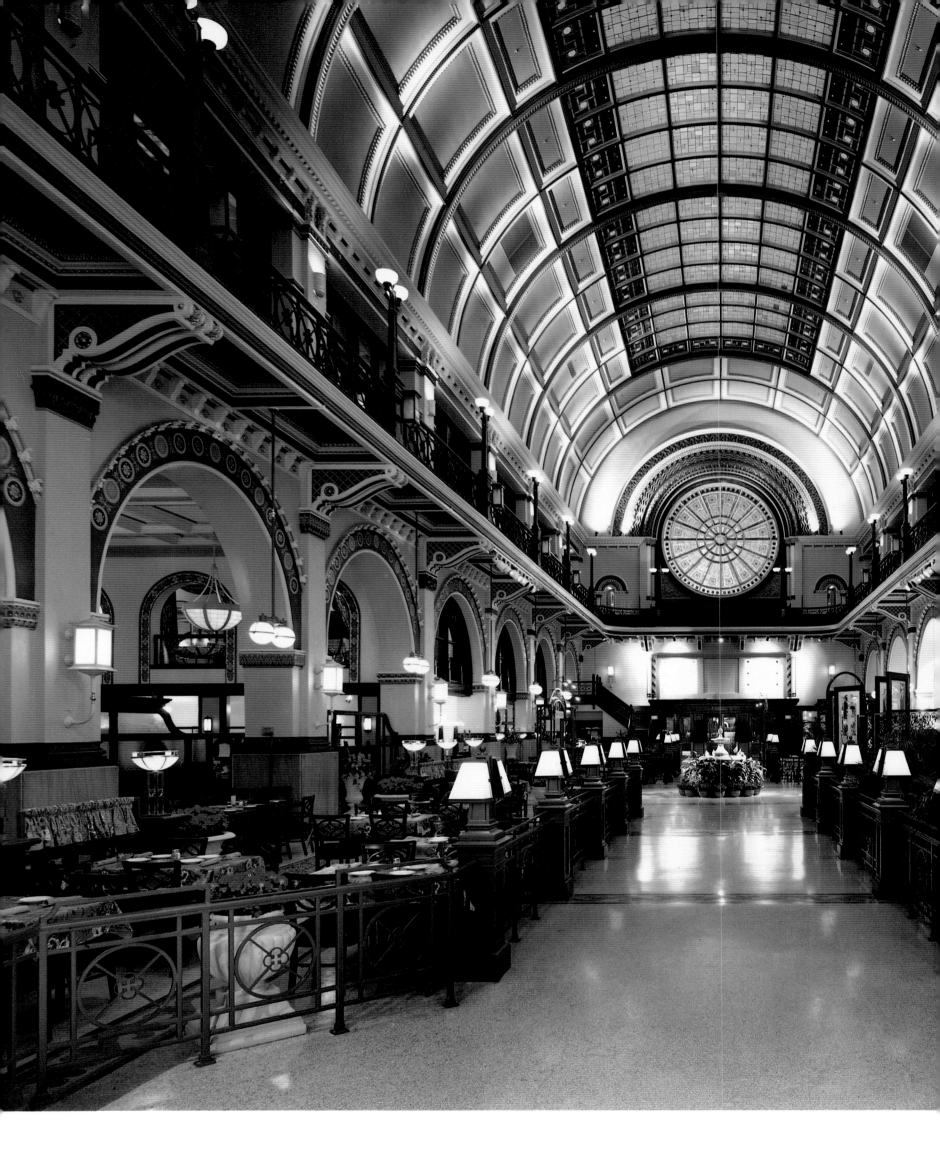

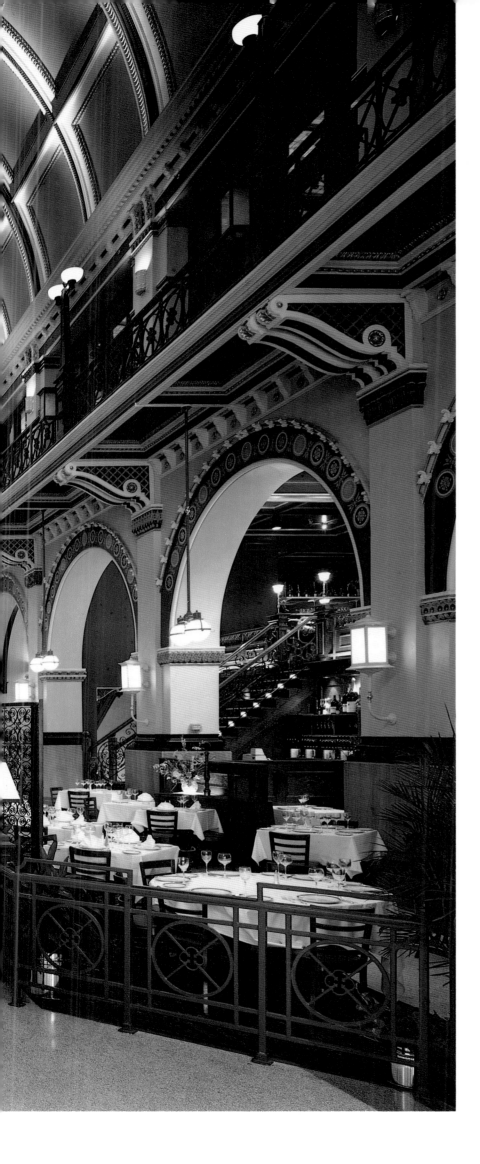

On the second level of the restored Union Station, a bevy of shops and eateries have replaced the trains. Included in the new look is a stage where young talents entertain.

Union Station's grandeur is there on the main level just as it was in the old days, though a portion of the space in what was known as the head house is now graced by dining tables. Still, looking to the rear of this picture, one almost sees the old central desk where all the latest information was provided on departures and arrivals to and from what many Hoosiers were convinced were mighty wonderful places.

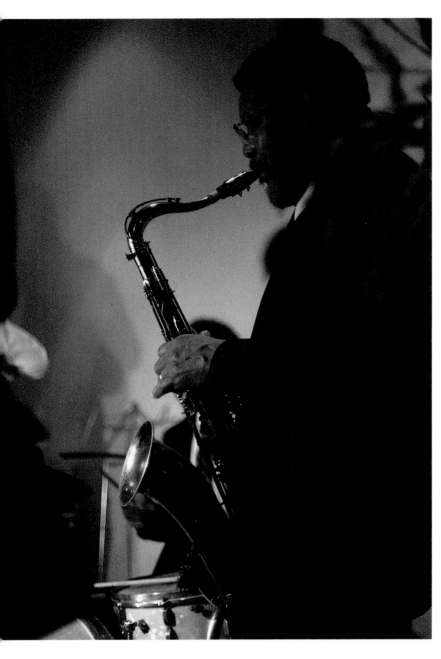

Jazz was for many years an important part of the scene on Indiana Avenue, not far from downtown. Clubs and bars where both black and white musicians flourished were there in abundance. Now the era has made a comeback (above), and jazz is heard frequently at gatherings in the recently restored Walker Building, named for a remarkable black businesswoman, the daughter of one-time slaves.

When the sun is out and the temperature bearable, many downtown workers like to spend a portion of their lunch hour at the City Market Plaza on Market Street across from the City-County Building. It has the potential for easing a stress-filled day.

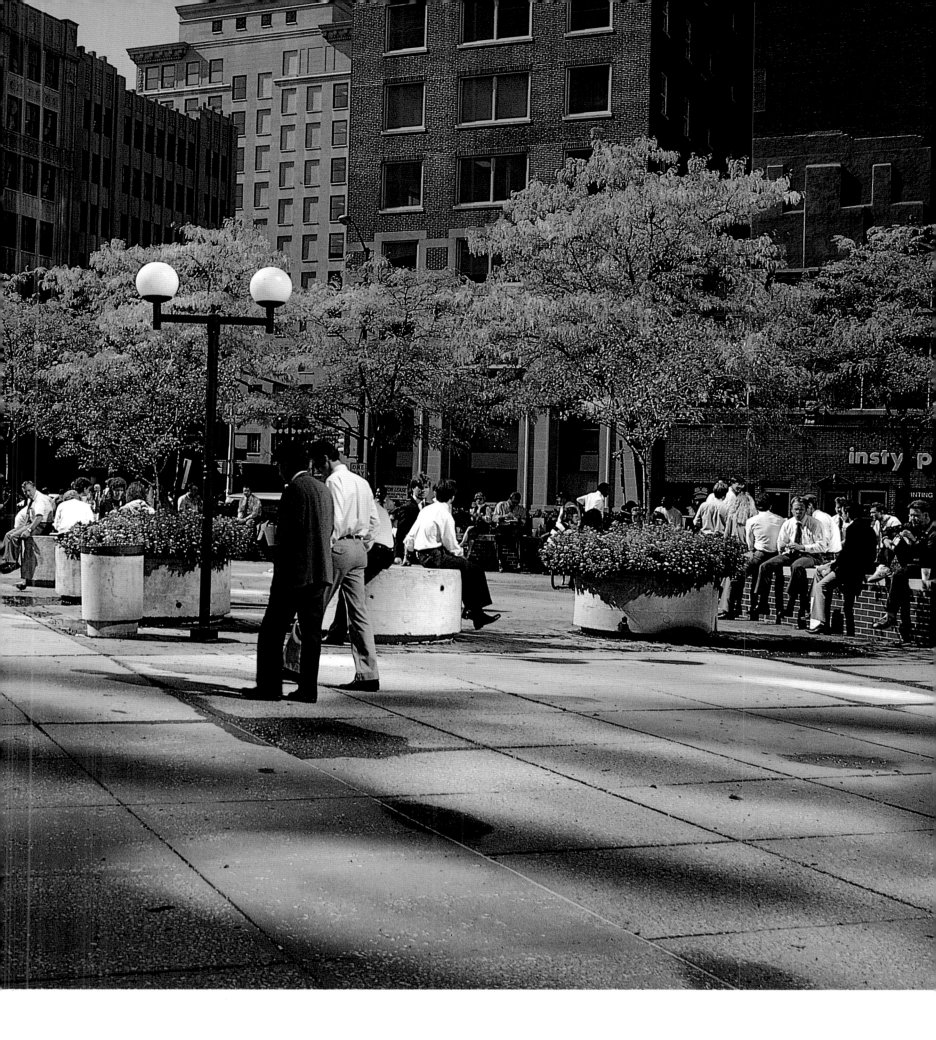

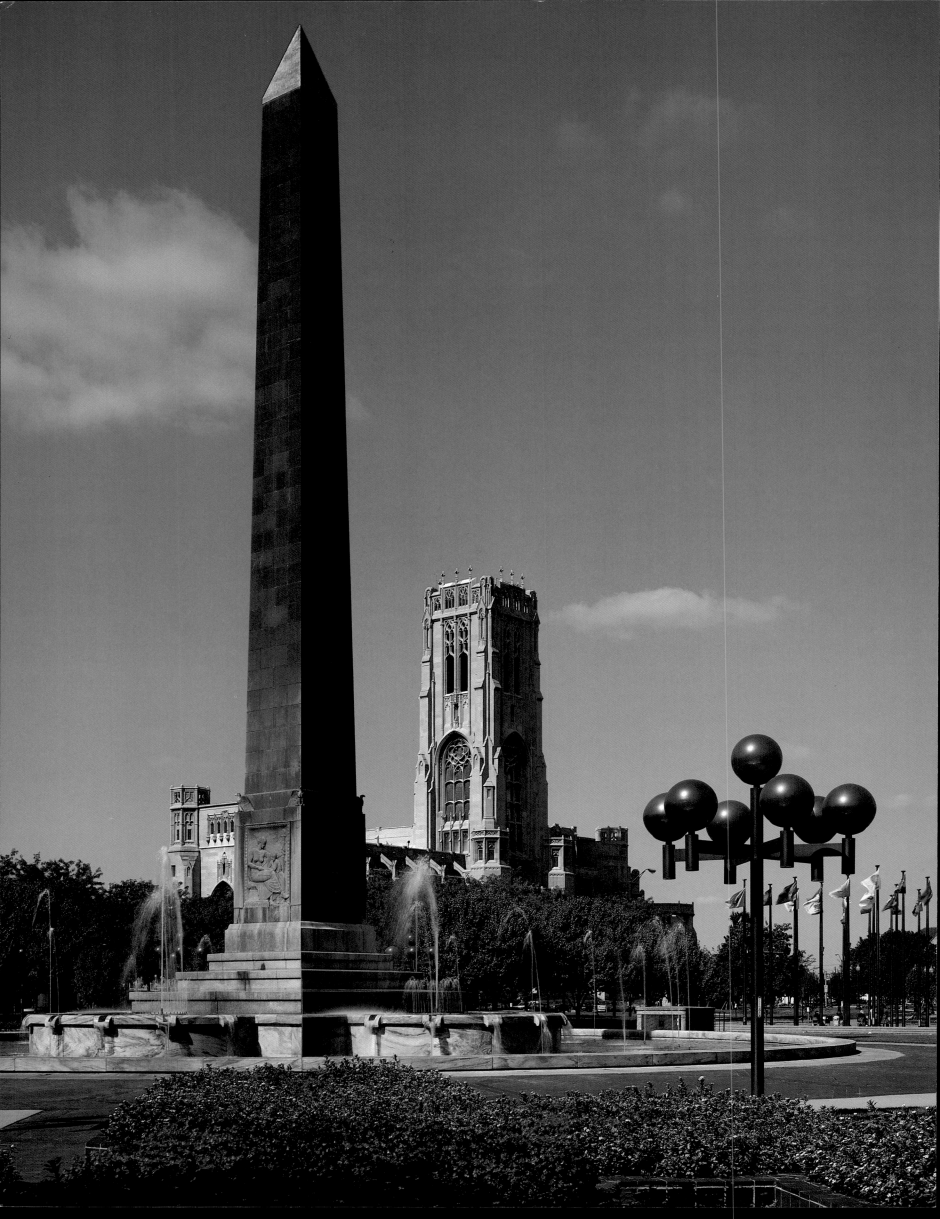

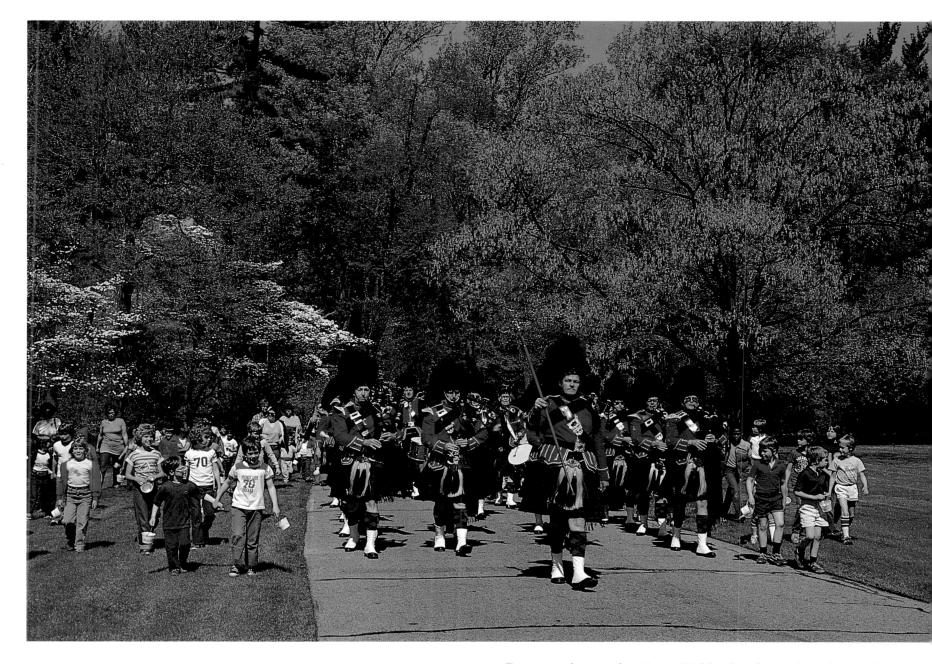

For several years the Murat Highlanders have played a part in the Governor's Annual Easter Egg Hunt on the grounds of the Indianapolis Museum of Art (above). Some 2,000 youngsters attend, and on this day many of them accompanied the Highlanders during the opening ceremony.

Obelisk Square (left) is a landmark on the five-block stretch of open space extending north from the World War Memorial to the American Legion Mall. The black granite obelisk was placed there in 1923, before the memorial itself was completed. The square includes a water fountain, two pink Georgia marble basins, and bronze sculptures representing law, science, religion, and education. To the right of the obelisk, west across Meridian Street, is the Tudor Gothic–style Scottish Rite Cathedral, one of the city's most intriguing buildings. Built of Indiana limestone by the Masonic Order's Scottish Rite, it was designated one of the seven most beautiful buildings in the world by the International Association of Architects after it was completed in the late 1920s.

41

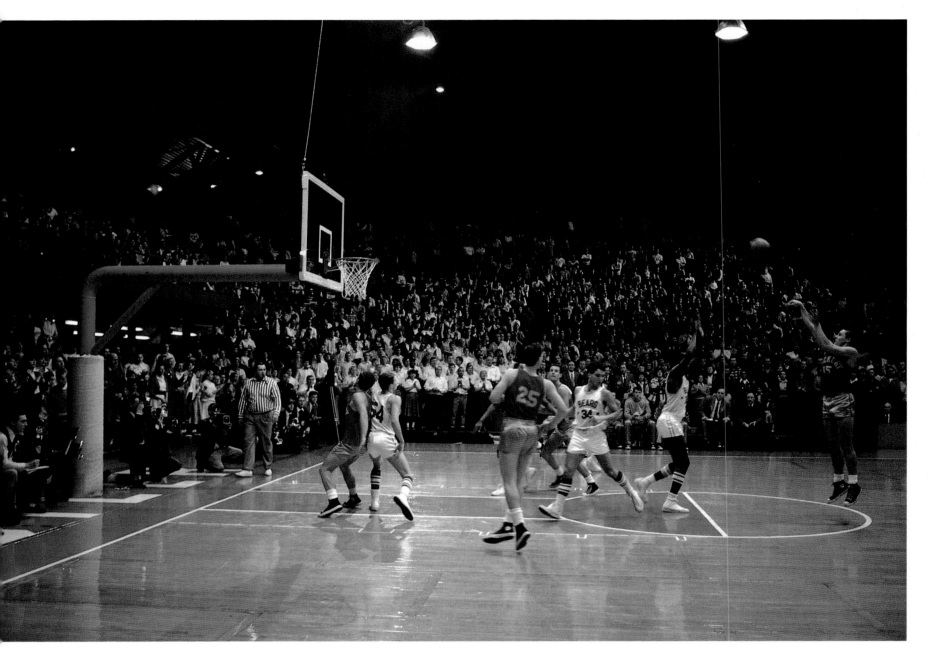

When Hollywood came to Indiana in the 1980s to film a story about Hoosier basketball based on the miraculous achievement of tiny Milan High School, it was inevitable that Butler University's fieldhouse would be a leading player. After all, it was the real-life setting for Bobby Plump's last-second basket that won the state title for the southern squad over a powerful foe in 1954. The scene was recreated for a day of filming on the movie *Hoosiers,* and all who wished were invited to come fill the stands dressed in 1950s fashions. Here we have the moment when the movie hero took his final shot. The ball can be seen leaving his hands. It went in, too.

Young Hoosiers grow up learning the importance of teamwork in basketball. In the 1960s some older Hoosiers applied similar tactics to a decaying area on the eastern fringe of the downtown area. Private agencies and public organizations got together to restore Lockerbie Square, providing an early model of teamwork that was used successfully on other city projects. At right is a typical example of a restored nineteenth-century home, one of many in the Lockerbie Square Historic District.

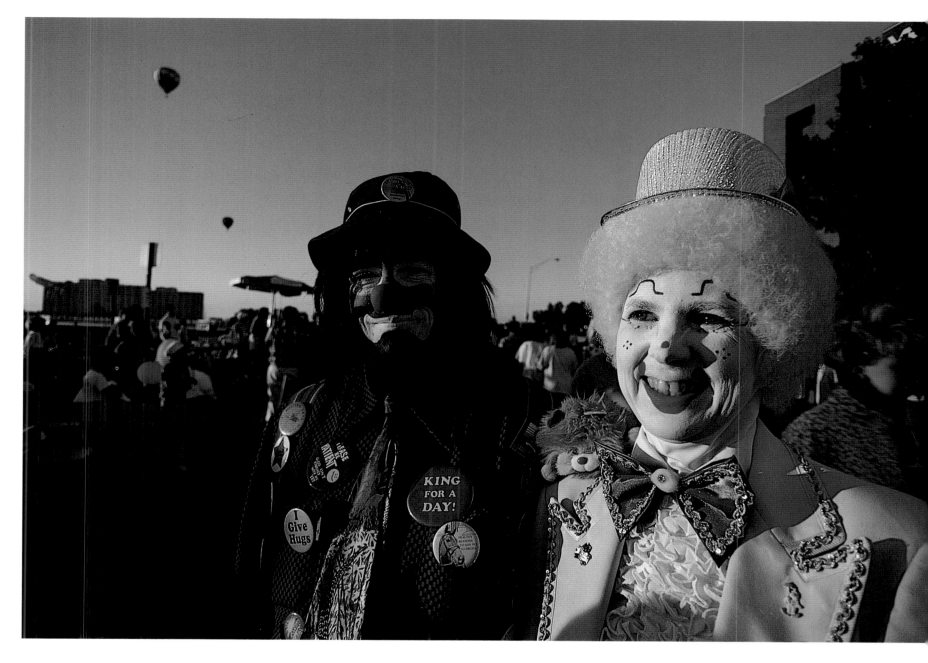

James Whitcomb Riley would have been pleased that the city frequently has downtown activities geared to attracting parents and children. The scene above was captured during the annual Labor Day weekend fireworks show over White River. The preliminaries bring out clowns and hot air balloons to delight the younger set.

The Historic Landmarks Foundation is credited with coordinating the public and private effort that worked so well in Lockerbie Square. That effort included a return to cobblestone streets, brick sidewalks, and gas lamps. The frame cottages at left were built in the 1860s. Lockerbie was the neighborhood of Hoosier poet James Whitcomb Riley, who wrote many verses about Indiana and its children. Riley lived on Lockerbie Street for the last 23 years of his life.

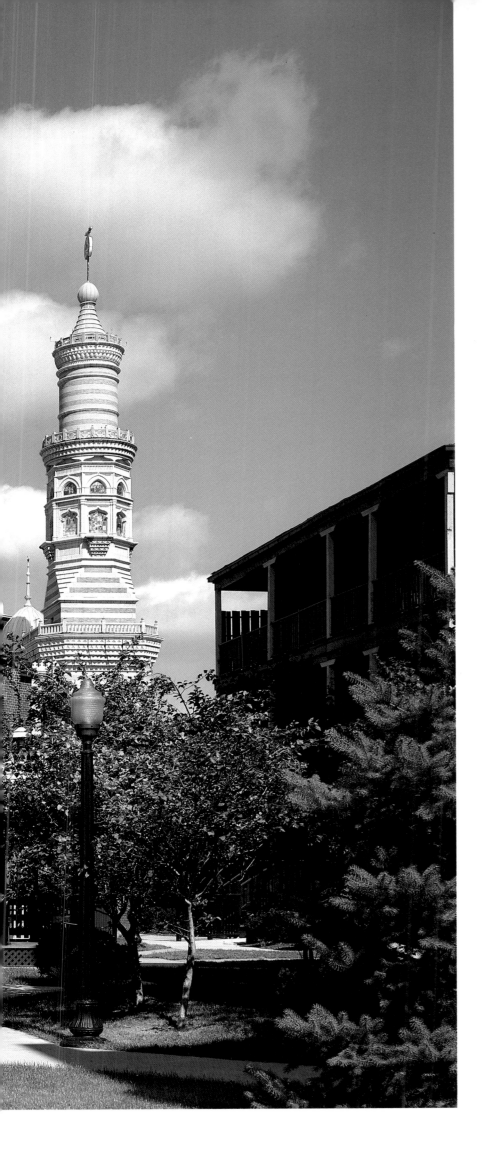

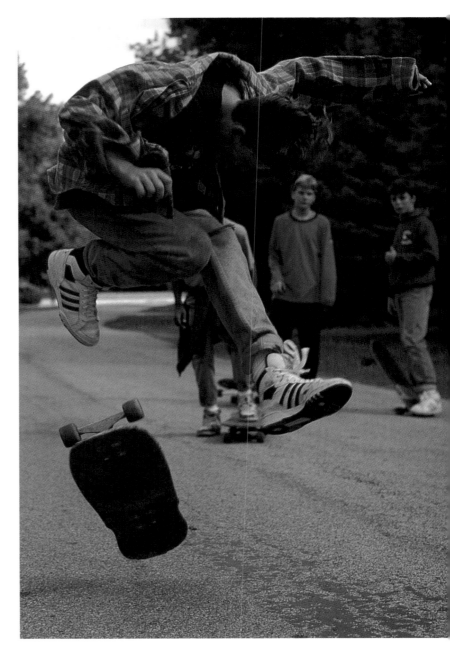

In a scene dominated by young skateboarders, the photographer seems to have caught some symbolism of the energy that has taken hold of downtown Indianapolis in recent years.

Proof of the success of restoration in Lockerbie Square is evident in this condominium complex called Lockerbie Court at New Jersey and Michigan Streets, one block east of the historic district. While the nineteenth-century architectural style was maintained, living quarters were revamped. To the right of the complex is the colorful Murat Shrine Temple with its domes and minarets, one of the largest temples in the world. Built by the Ancient Arabic Order, Nobles of the Mystic Shrine, it opened in 1912. Its sizable interior, featuring Arabian and Egyptian themes, includes the oldest surviving theater in the city.

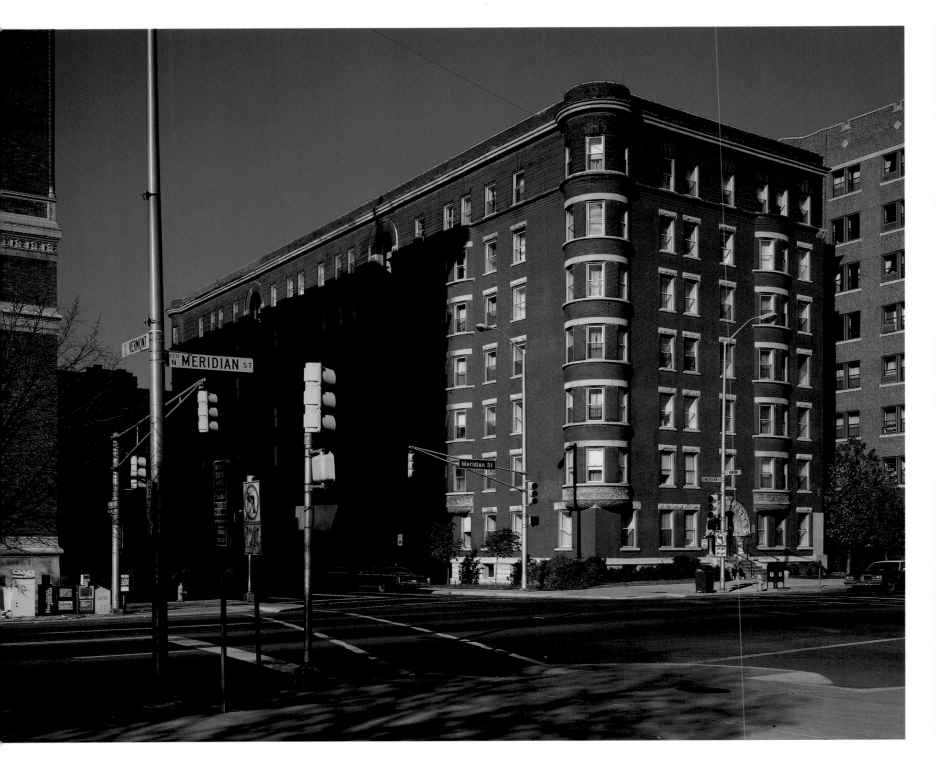

Structures on the near northside were restored in recent years to provide desirable federally subsidized living space for low-income residents. A notable example is the 90-unit red brick Blacherne building on North Meridian (above). Dating back to the 1890s, the Blacherne was the city's first luxury high-rise apartment building. Private investors now plan to return the building to what they call "market-rate housing," displacing its low-income residents to new structures elsewhere.

Since the 17,000-seat Market Square Arena opened downtown in the early 1970s, it has served as home for the city's professional basketball franchise, the Indiana Pacers. A site as well for many other kinds of entertainment, the Arena was one of the early major efforts to attract people back downtown.

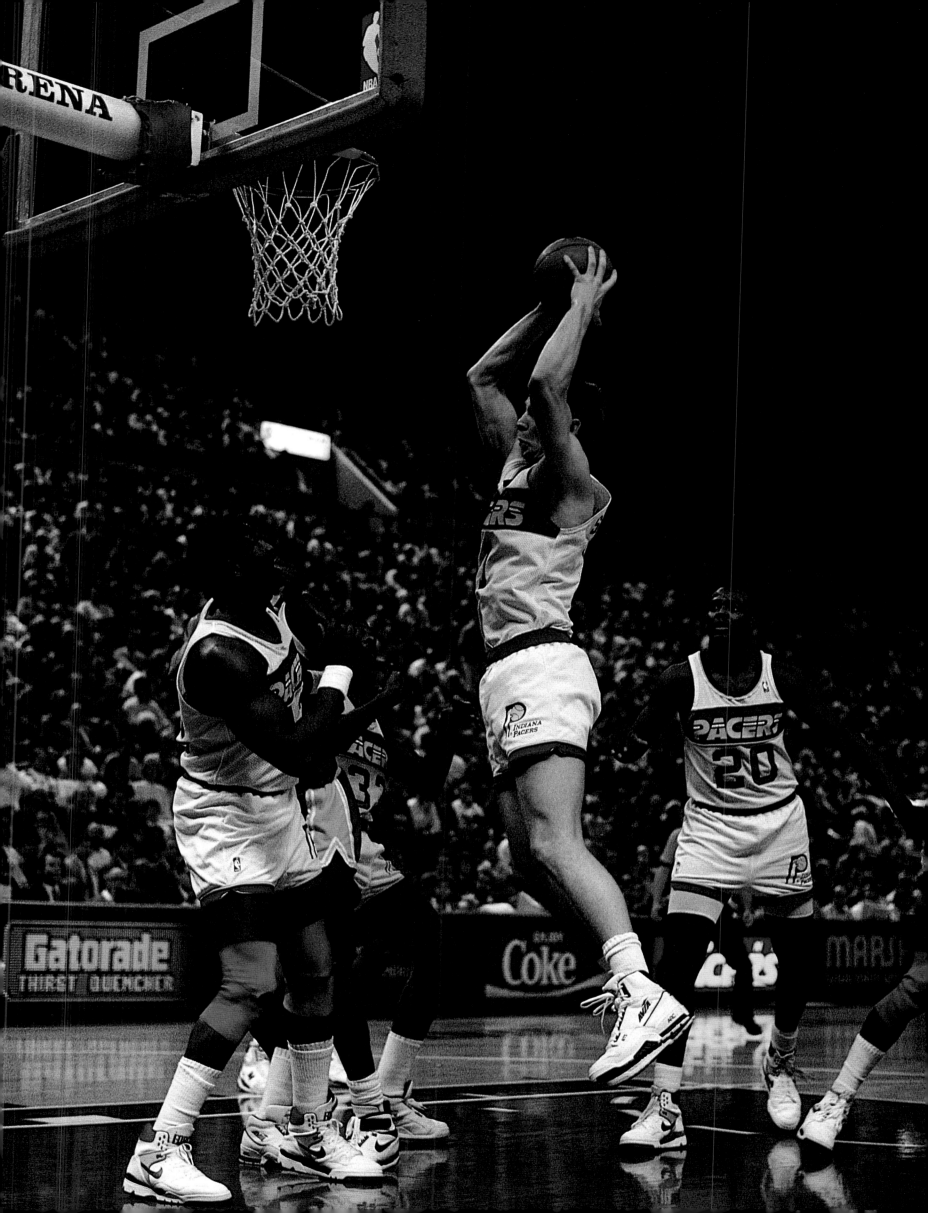

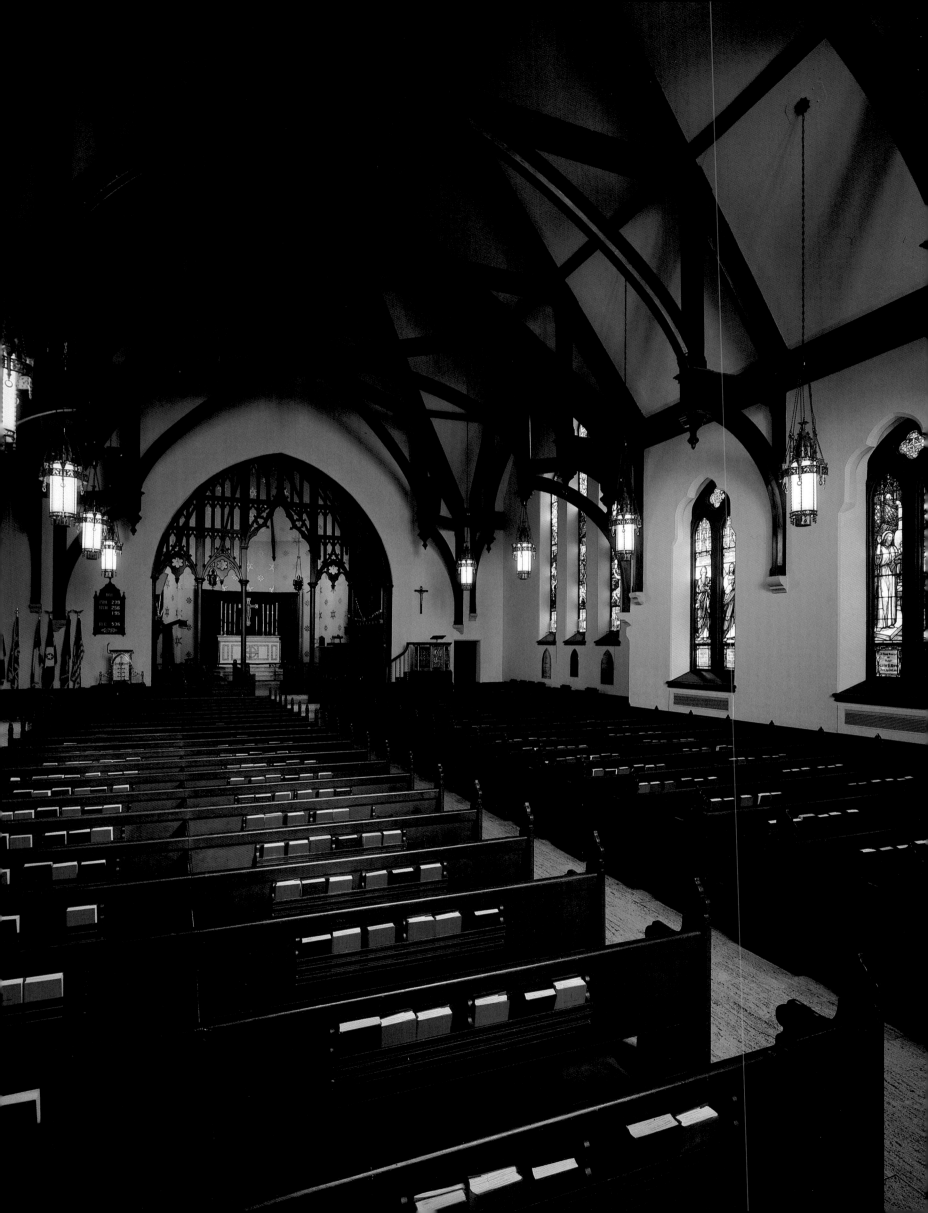

The picturesque courtyard is at Riley Hospital for Children on the city's near westside. Riley, built in the 1920s, deals exclusively with the health and medical problems of the young. It is the only hospital of its kind in the state.

Indianapolis has a long history of professional baseball, far longer than most cities. Since 1931, games of the Indianapolis Indians have been played in what is now called Bush Stadium, named for Owen Bush, a player and later manager of the team. This action (overleaf) was captured during a twilight doubleheader.

Christ Church Cathedral (left) has the distinction of being the oldest building on Monument Circle. It was constructed in the late 1850s, but its beginnings go back even further to the 1830s.

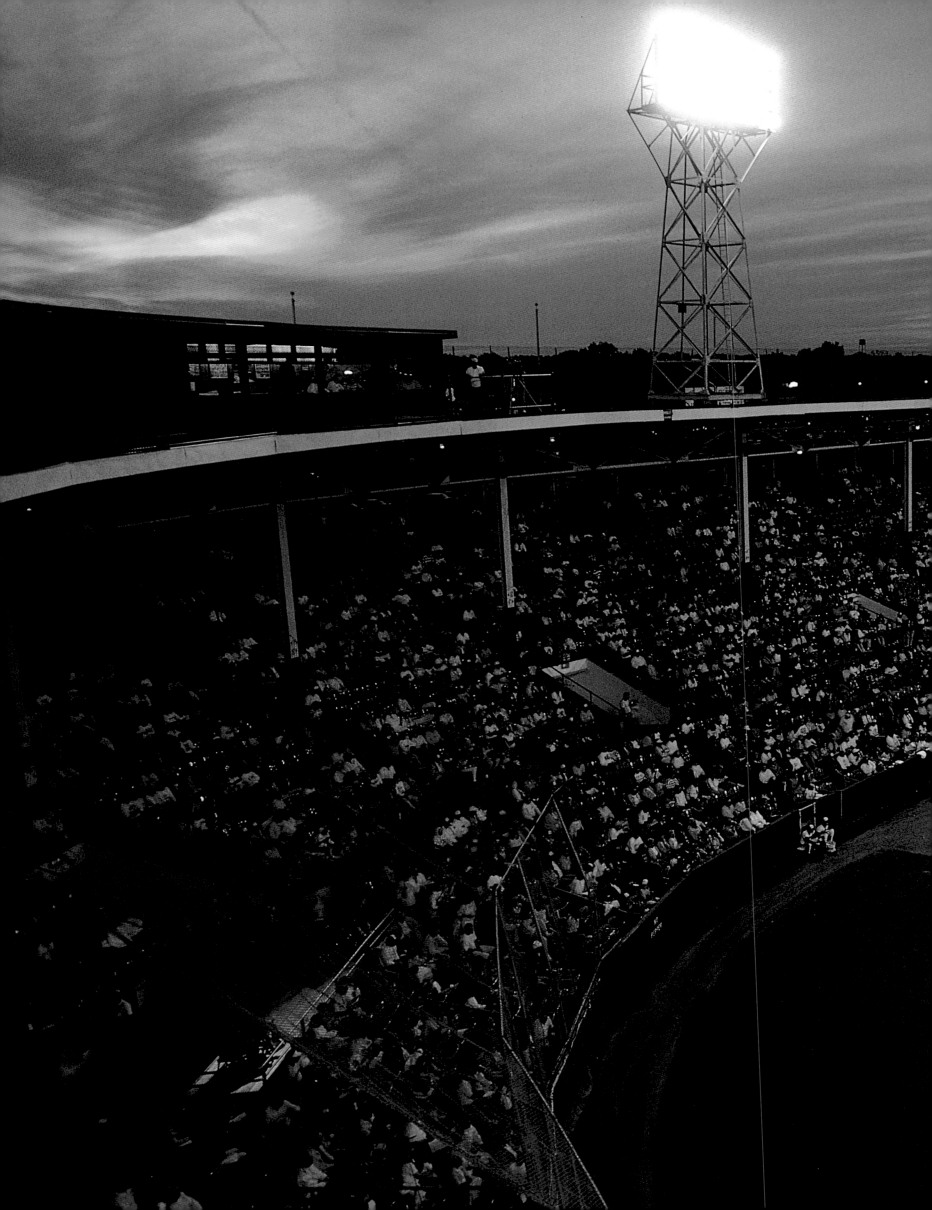

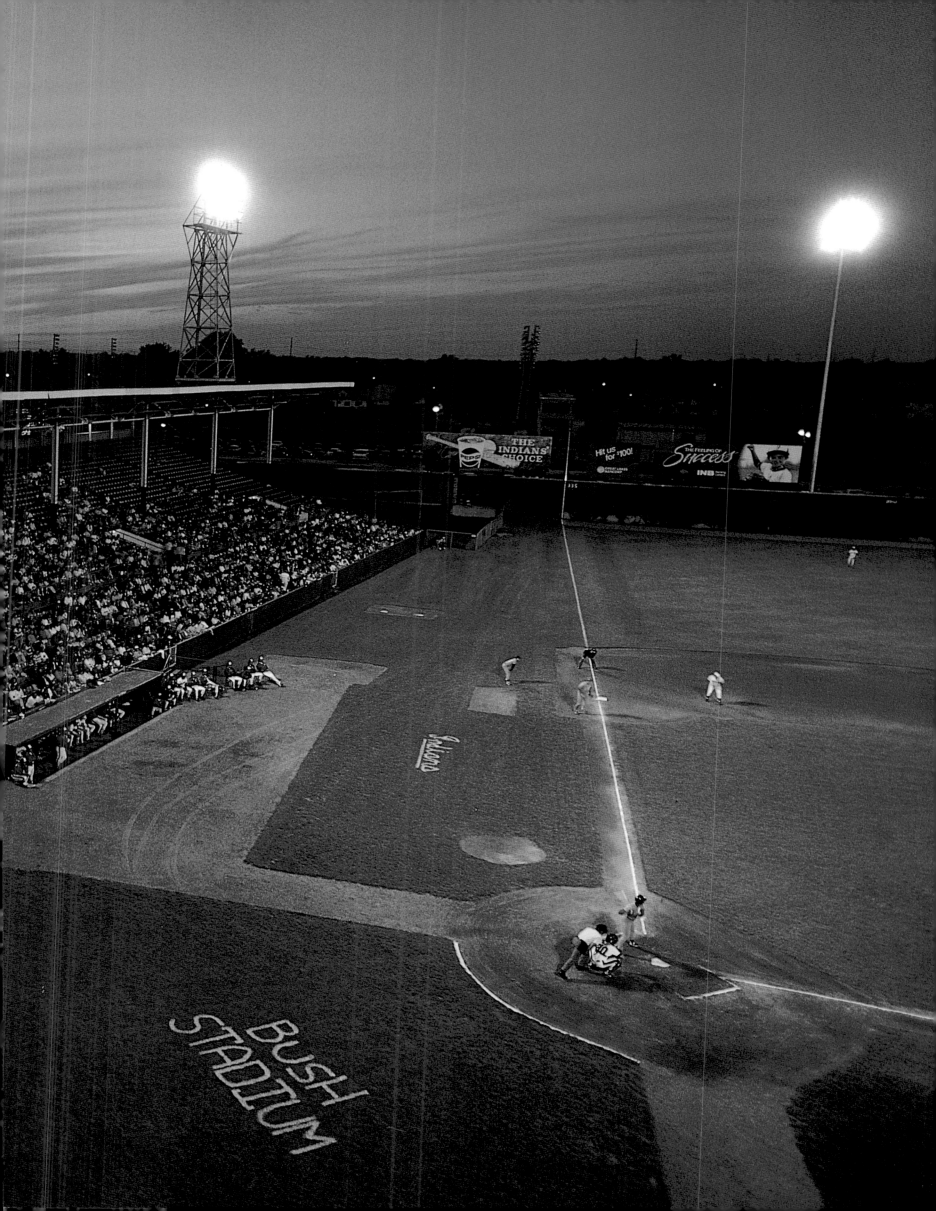

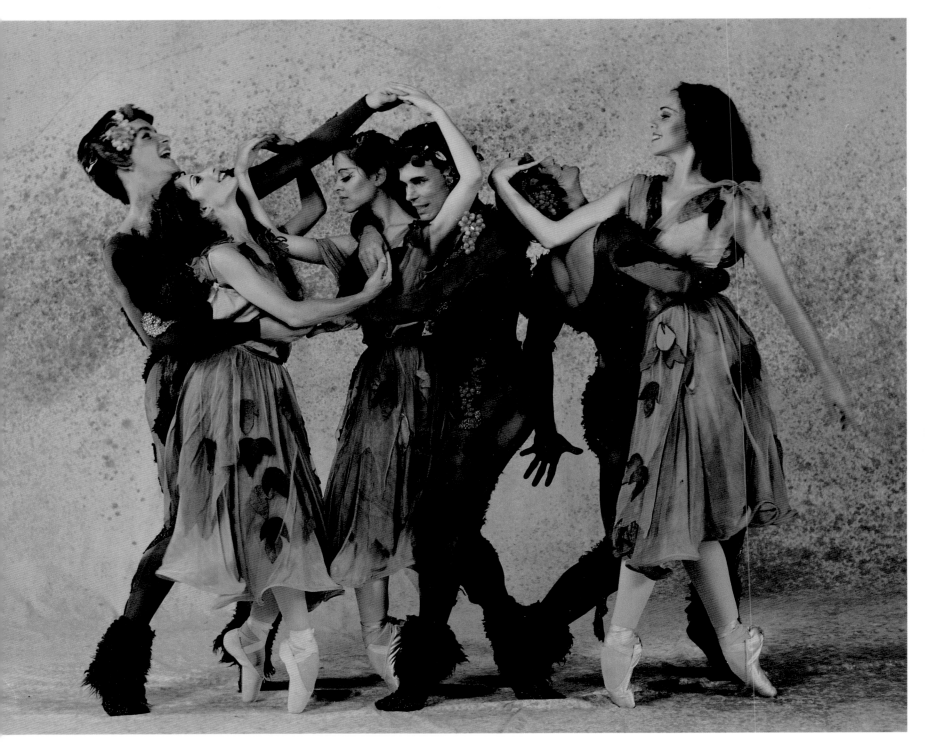

The city's cultural life is greatly enhanced by such groups as the Indianapolis Ballet Theatre (above), made up of full-time professionals. The dance group's repertoire includes classical as well as contemporary and original works, and its season includes tours both in and outside the state.

The Indianapolis Symphony Orchestra added dignity to downtown when it moved its home to the restored Circle Theatre, the city's first movie palace, on Monument Circle. The theater's corporate neighbor, Indianapolis Power and Light, played a key role in saving it from a wrecker's ball. The orchestra reopened it in 1984.

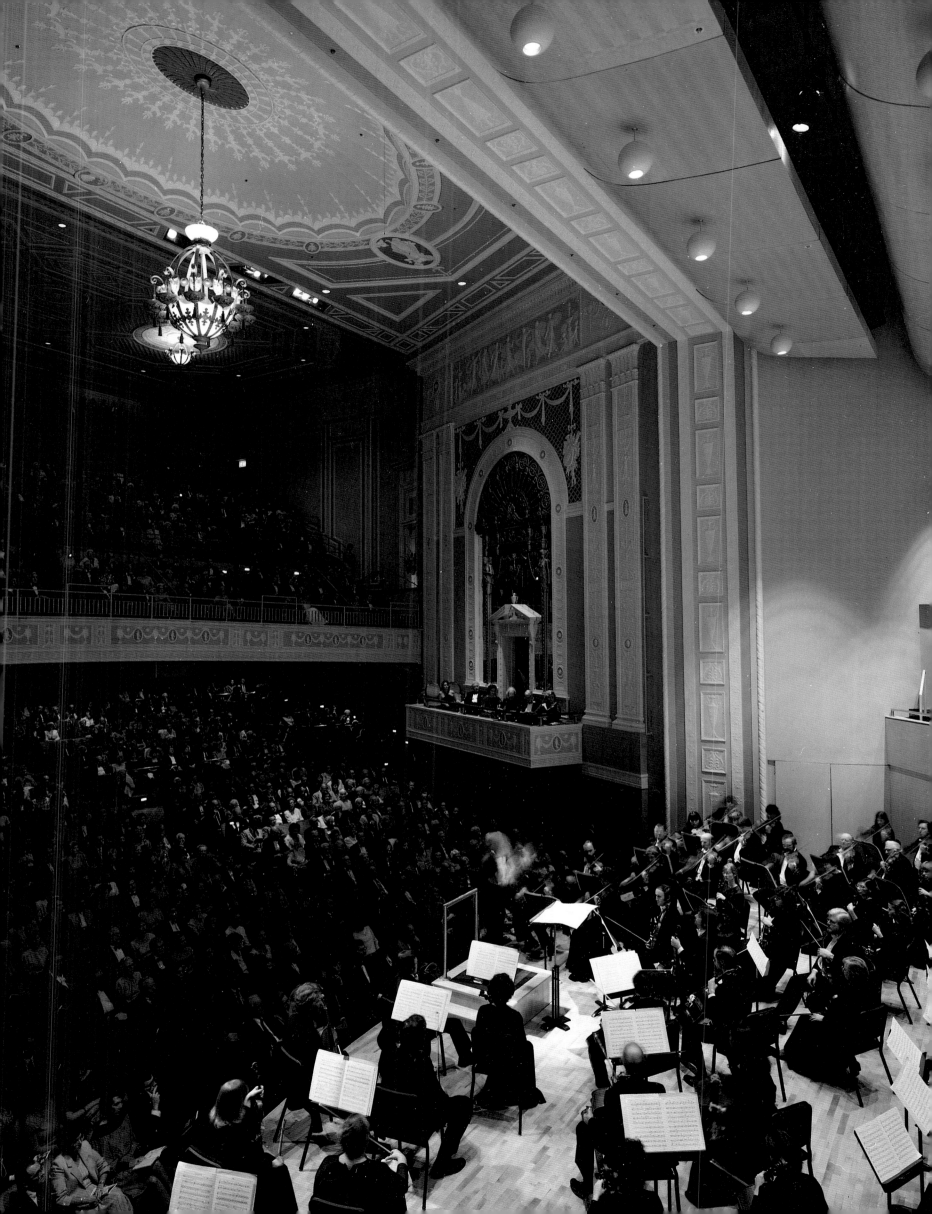

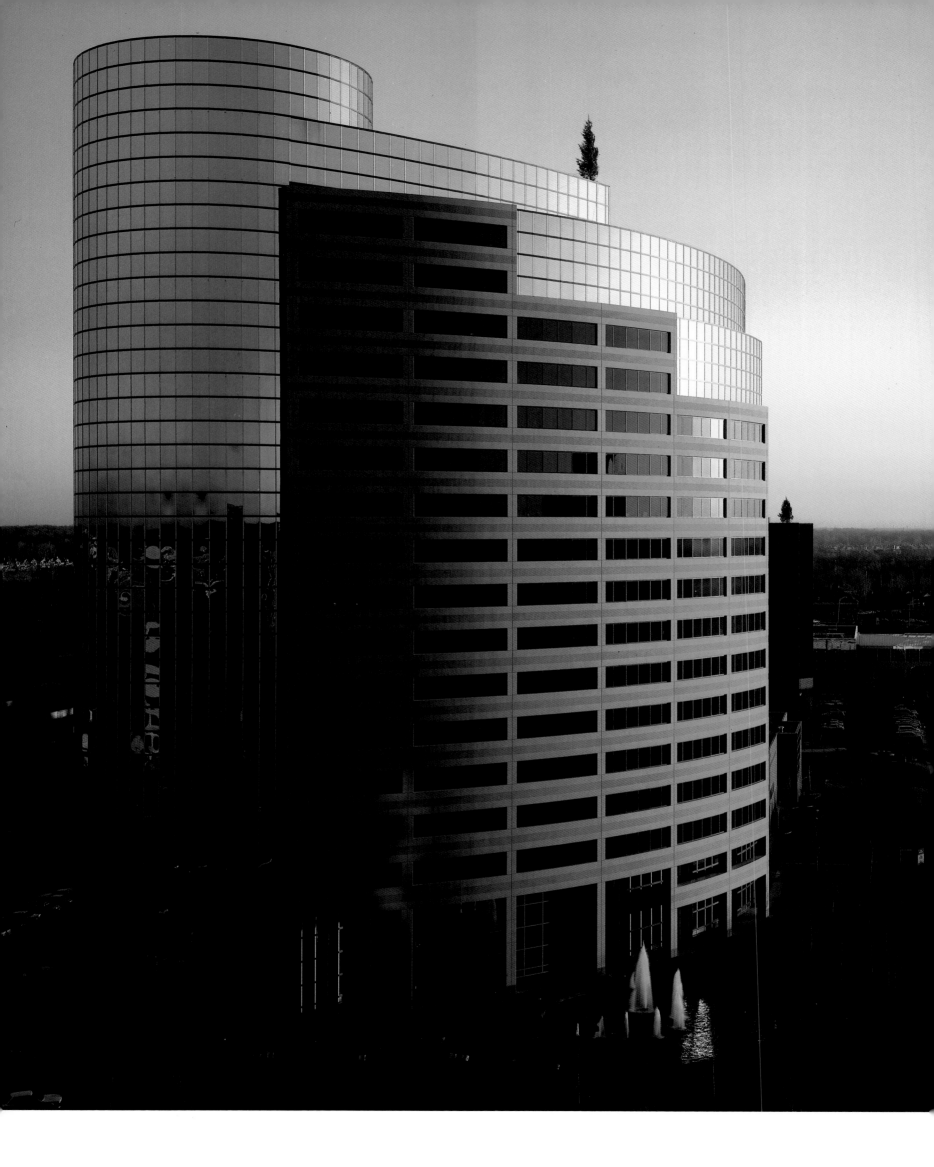

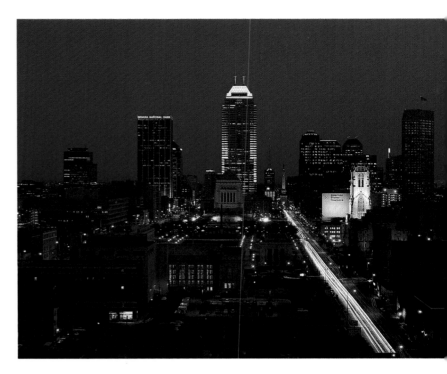

The city at dusk from the Landmark Center at 10th and Meridian.

New commercial construction has not been confined to the downtown area in the 1980s. One large northside office building at Keystone at the Crossing complex houses, among other businesses, a key suburban developer, P.R. Duke and Company. In the background is the newly renovated Fashion Mall with the Indianapolis skyline on the horizon.

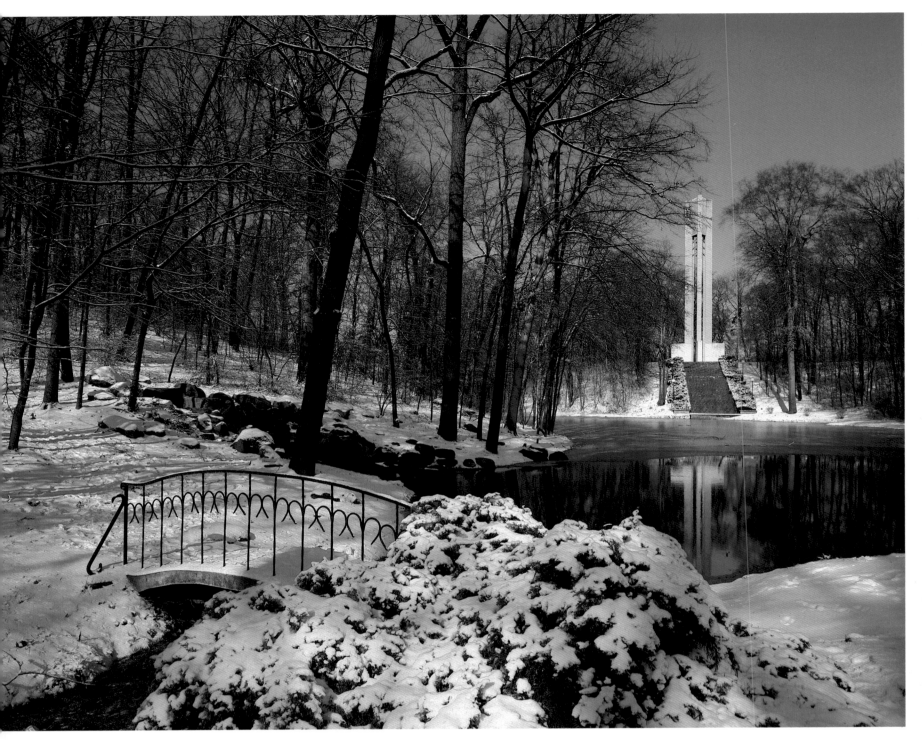

Butler University has added buildings through the years, but it has preserved its wooded sections, too. This winter scene shows a northwest segment of the 300-acre campus, with the Musetta Holcomb Memorial Carillon across the pond.

58

Indiana's only citizen to serve in the White House, Benjamin Harrison built this home on North Delaware Street fourteen years before he ran for president in 1888. Though he was a native of Ohio, Harrison was linked for most of his adult life to Indiana and his home in the state capital. He returned after he was defeated for a second term and lived here until his death in 1901. A special presidential cane, given to Harrison when he completed his four years in the White House, rests near a chair in the Gold Room.

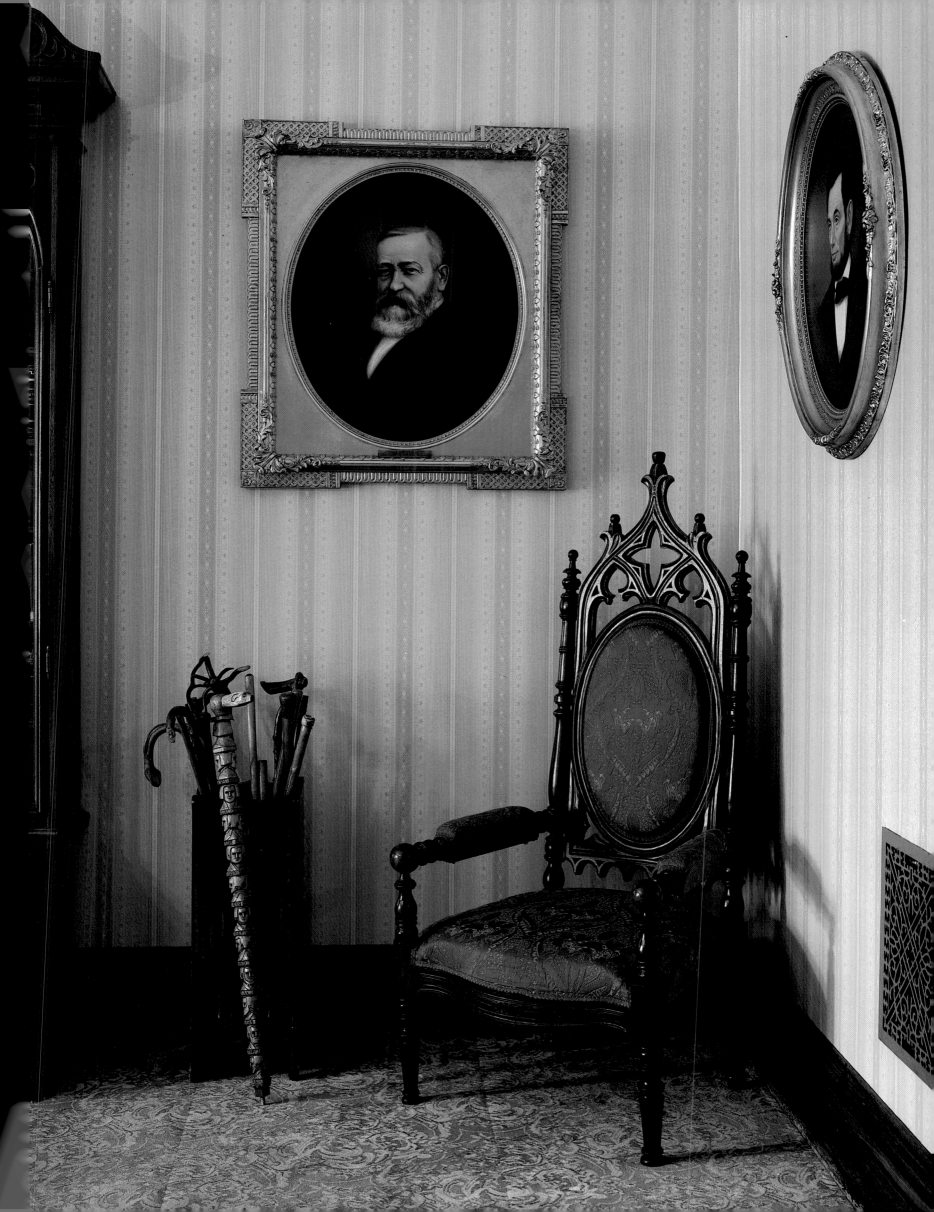

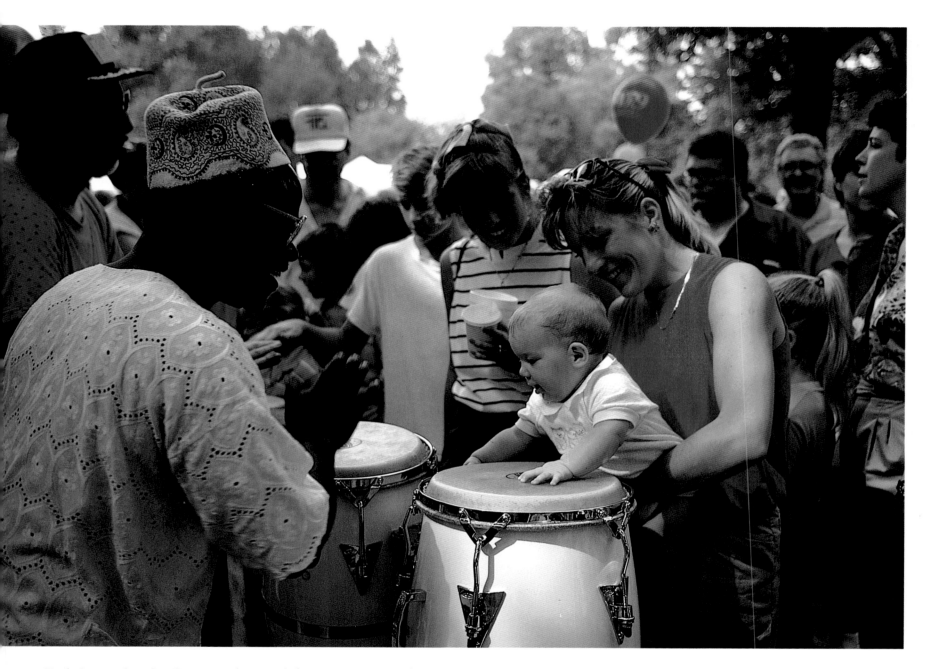

Each September families in and around the city swarm to the grounds of the Indianapolis Museum of Art for the Penrod Art Fair. Here one young visitor examines a drum used by Drums of Africa, a local group of African-born musicians. The Penrod Society is committed to making people aware of the large variety of cultural life available to them in the city.

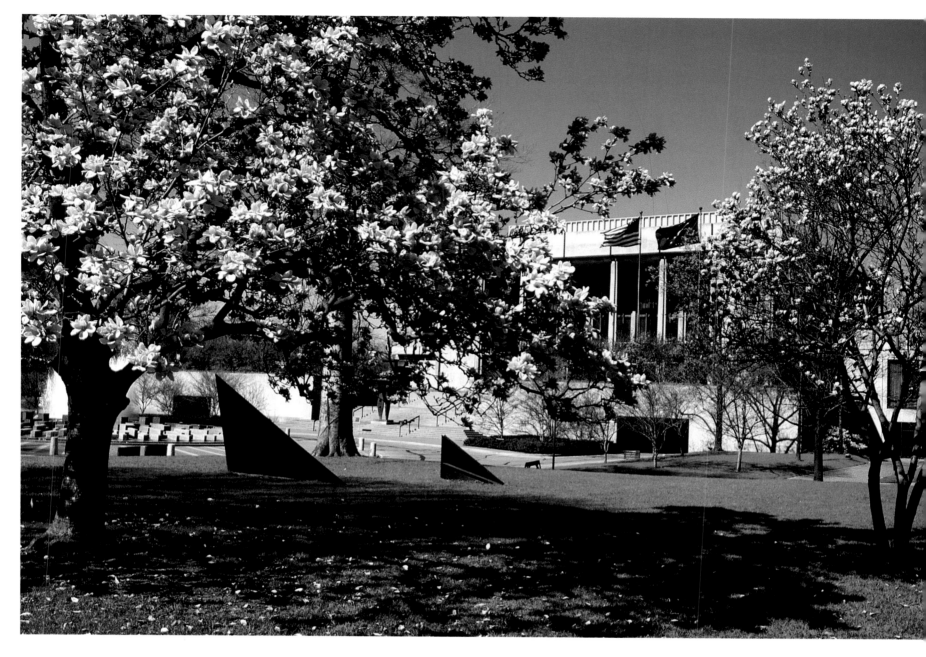

Magnolias in abundance on a spring day threaten to conceal the art museum's main exhibition building. The grounds and a home were a gift of the J. K. Lilly, Jr., estate. The museum contains the Clowes, Krannert, and Showalter Pavilions, which house the permanent collections. Exhibit space has doubled with an additional pavilion and some renovation.

Anyone who has driven by this old home (overleaf) on Kessler Boulevard a few blocks west of Chatard High School in the Broad Ripple area will recognize this burst of color. The collage of flowers that fill the yard has a special impact in spring, the season when this picture was taken.

61

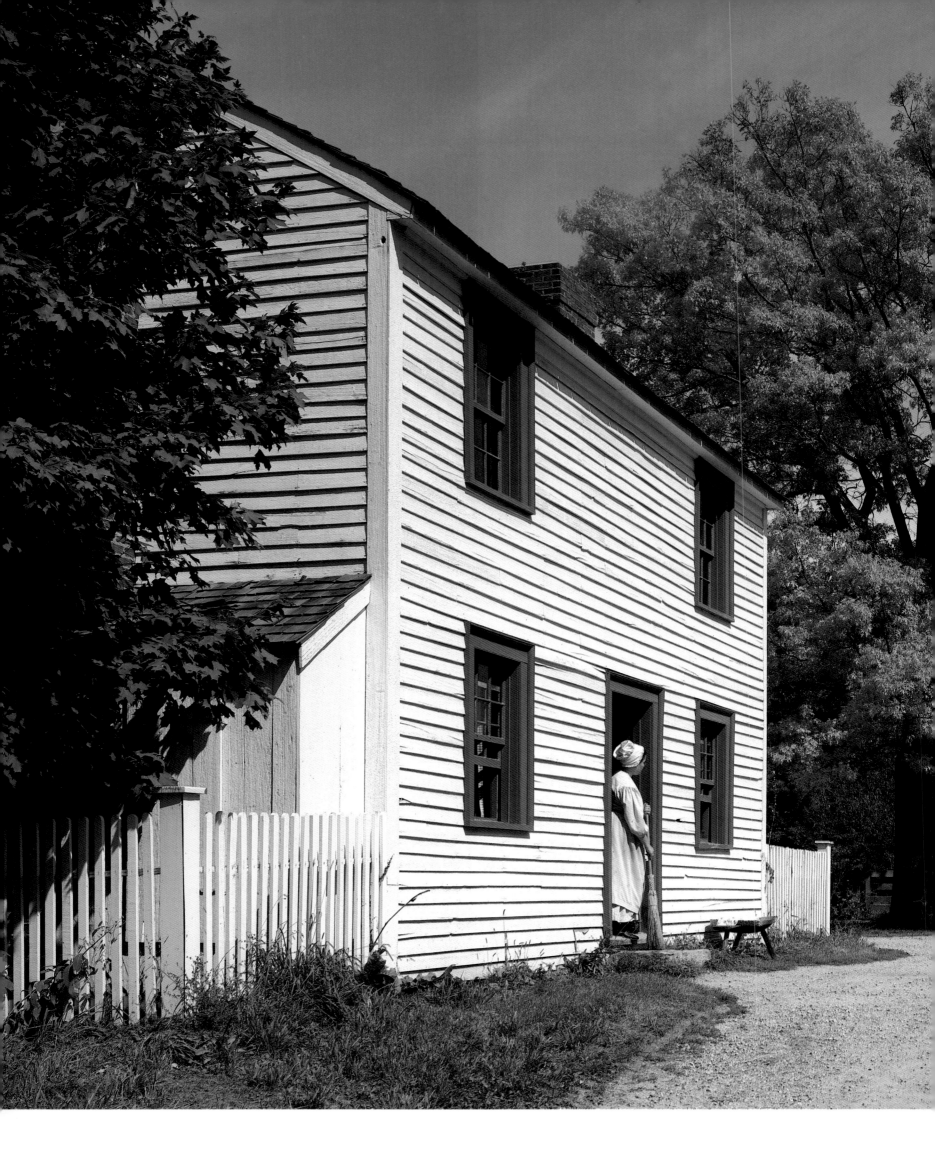

There is a vital link between Conner Prairie and Indianapolis. The land where the pioneer settlement now stands was originally owned by William Conner, who lived in the brick house at right above. In 1820, members of a state commission met in this house and decided that a new state capital should be built—and that is now Indianapolis.

This white frame house is one of 39 restored structures that make up a recreated village of 1836. Conner Prairie Pioneer Settlement is an outdoor museum with guides who assume the roles of ordinary people to give visitors a look at everyday Hoosier life when the state was young. The village is in Hamilton County, a few miles northeast of Indianapolis.

A suburb for many years, Broad Ripple has evolved into an urban area attracting relatively young Indianapolis residents. One of them stopped for a moment during a shopping trip to pose for Photographer Jones with the son of a Broad Ripple shop owner. The two residents represent age categories that are prevalent in the area today.

Suburban Zionsville made a giant leap into ambitious restoration in the 1960s (left). Its main street was paved with brick and planters, and gas lamps were placed along the route. New buildings conform to nineteenth-century architectural styles, and many homes from that era have been converted to specialty shops and restaurants. Zionsville is just outside Marion County, in the southeastern corner of Boone County.

Broad Ripple (above) is one of the city's residential and business sections that coped well with the problems of changing populations and commercial patterns in the 1950s and 1960s. Many residents were moving out to new suburban areas, and shopping centers were proliferating to serve them. Broad Ripple merchants worked together to encourage shops, eateries, and nighttime attractions that would appeal especially to the young.

Shortly after World War II, businesses started moving north out of downtown, sometimes into large old converted homes and sometimes into new but modest structures. In the 1980s the movement reached new dimensions with buildings such as this one at 116th and North Meridian Streets in Hamilton County near Carmel. Note the tie-in with Indianapolis, however: the street numbering sequence conforms to the city's, both here and all the way north through Hamilton County on Meridian, which becomes U.S. 31.

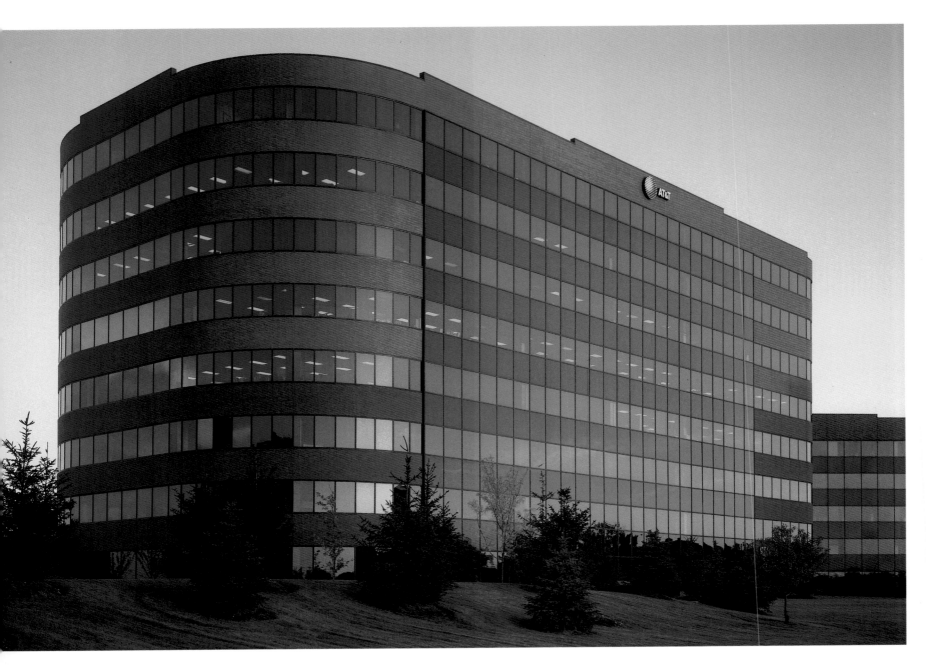

A prime example of commercial operations that moved into the northern sections of the metropolitan area and enhanced their appearance is the AT&T building. Traditional landscaping complements its shiny newness.

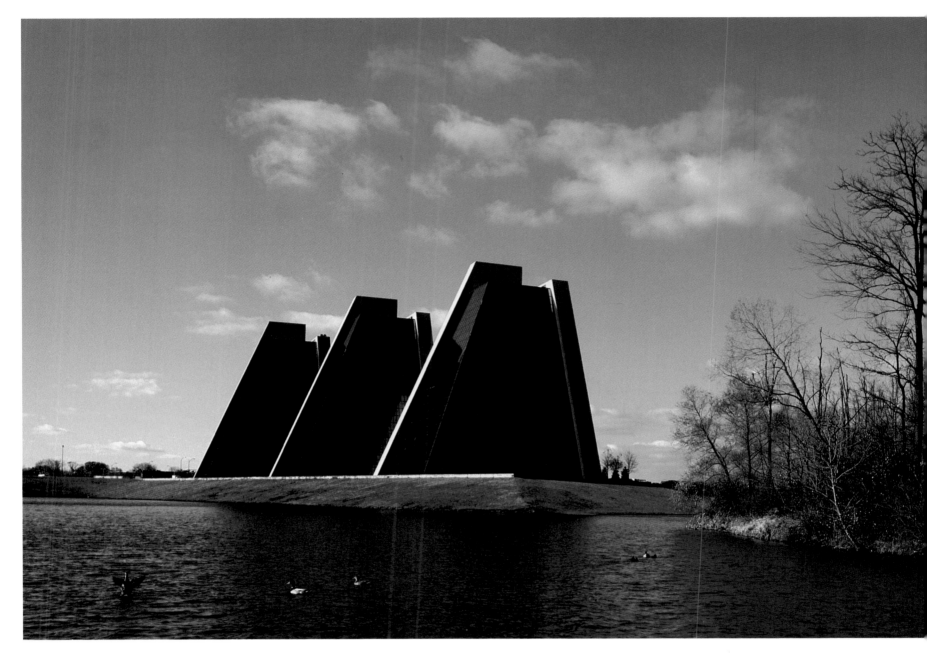

One point on which everyone can agree is that College Park Pyramids catches the attention. That happens whether one is airborne or traveling on an interstate in the northwest part of the city. The commercial-residential development went up in the early 1970s, well ahead of its time for Indianapolis. Considered an outstanding example of modern architecture, the Pyramids office complex has been the subject of praise, considerable criticism, and, at times, jest.

Fox hunting has had a following in the Indianapolis area since the early 1930s, when the Traders Point Hunt Club was formed. The club's main grounds (overleaf) are northwest of the city. The regular fox-hunting season runs six months, from fall through the winter. Members say the foxes are seldom injured. Current membership at Traders Point, counting families and individuals, is 125.

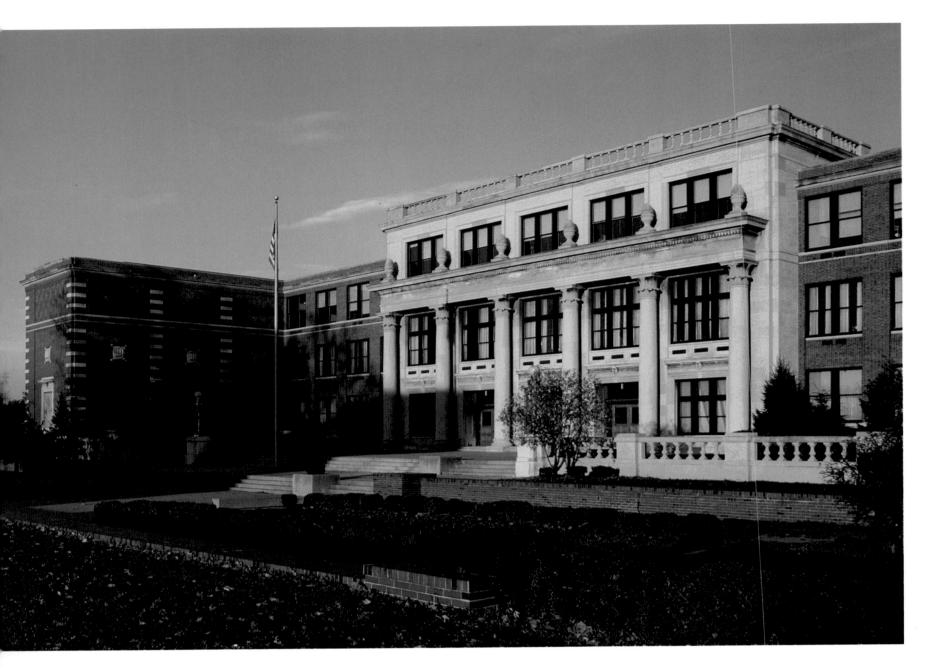

These two structures, easily identifiable by anyone who grew up in Indianapolis, are but a few blocks from one another. Both date to the latter half of the nineteenth century.

Shortridge (left) opened in Civil War times as the city's first high school. It became one of the nation's premier college preparatory schools with a long list of successful graduates. Many of these graduates are still in leadership roles here and across the country. Population shifts and shrinking inner-city enrollments doomed the institution as a high school by the end of the 1970s. The building still survives, however, as Shortridge Junior High.

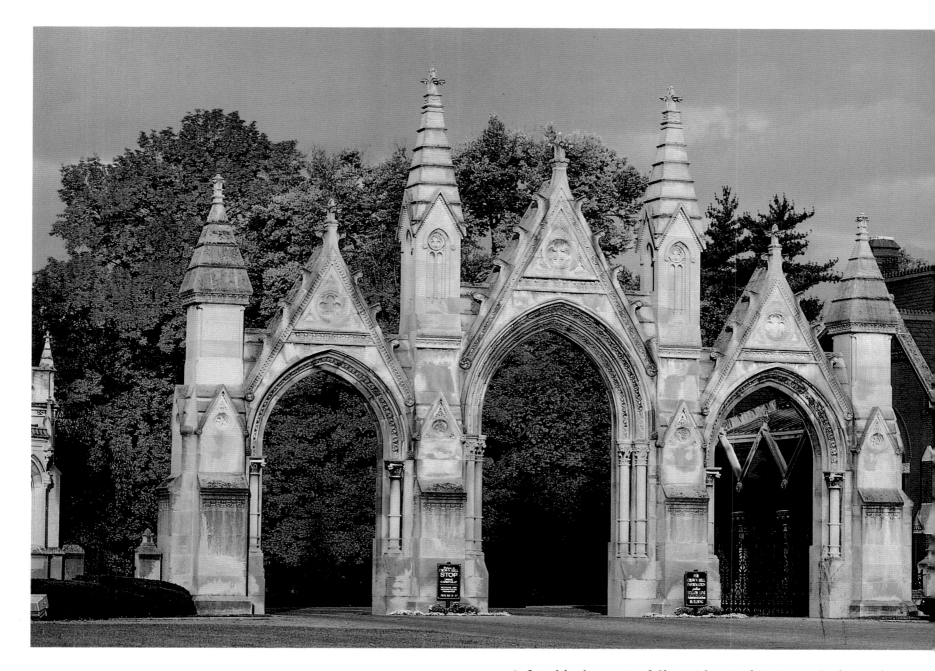

A few blocks west of Shortridge is this stone Gothic-style gateway to Crown Hill, now considered to be the nation's fourth largest cemetery. It is the final resting place of thousands of Indianapolis citizens, including some of extreme prominence, such as James Whitcomb Riley and President Benjamin Harrison. The funeral procession of Vice-President Thomas A. Hendricks was the first to pass through these gates, which were erected at the 34th Street entrance in the mid-1880s.

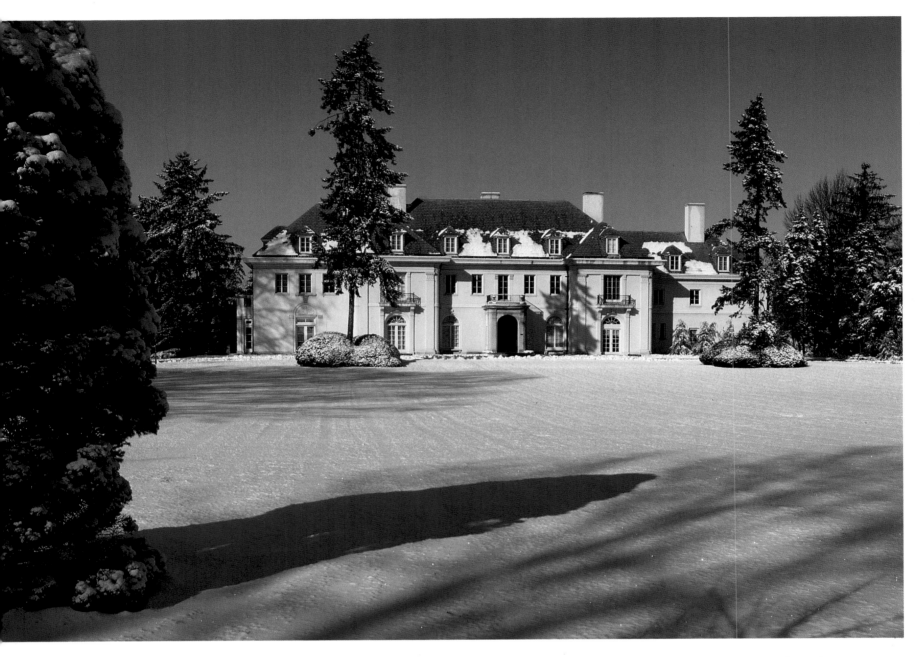

Two Indianapolis homes, built about the same time, serve very different purposes in the city today. One of them, filled with valued treasures and finery, is open to the public. The other, once the home of one of the city's most successful authors, continues as a private residence.

Oldfields (above) is a 22-room mansion with furnishings, both American and European, from the eighteenth and nineteenth centuries. Built in 1912, it also contains paintings by the great masters. It and its grounds were given to the Indianapolis Museum of Art by its last private owners, the Lilly family, and it is open to the public.

The English Tudor–style mansion (right) built in 1911 near 42nd and North Meridian Streets became the home of Booth Tarkington, who twice won the Pulitzer Prize for his novels, both with story lines linked to his hometown. Tarkington converted the third floor into a large writing room, and many of the ideas for his novels were born there. A number of them found their way to the Broadway stage and Hollywood. Stories still abound about parties at Tarkington's home with leading actors and actresses of the time as guests. Tarkington died here in 1946.

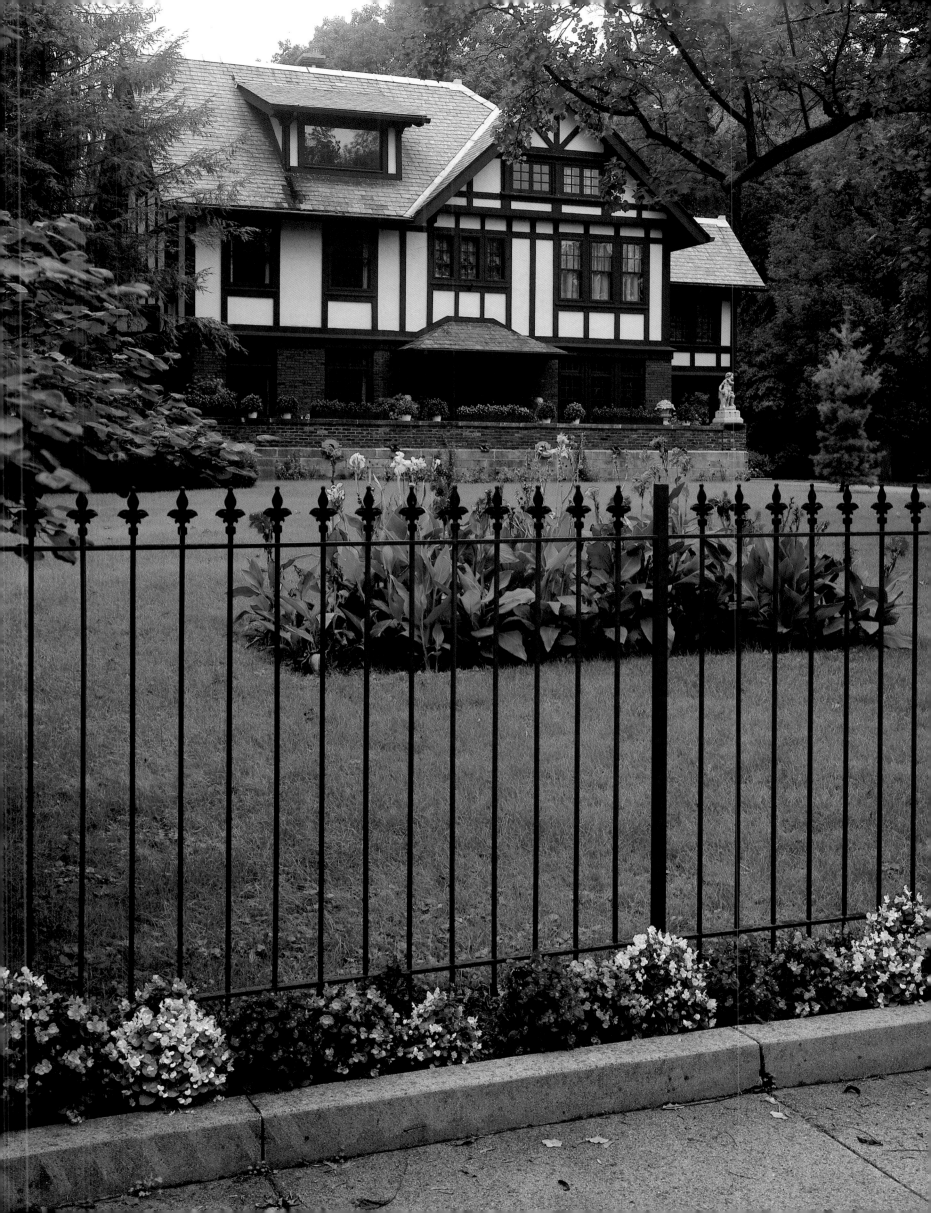

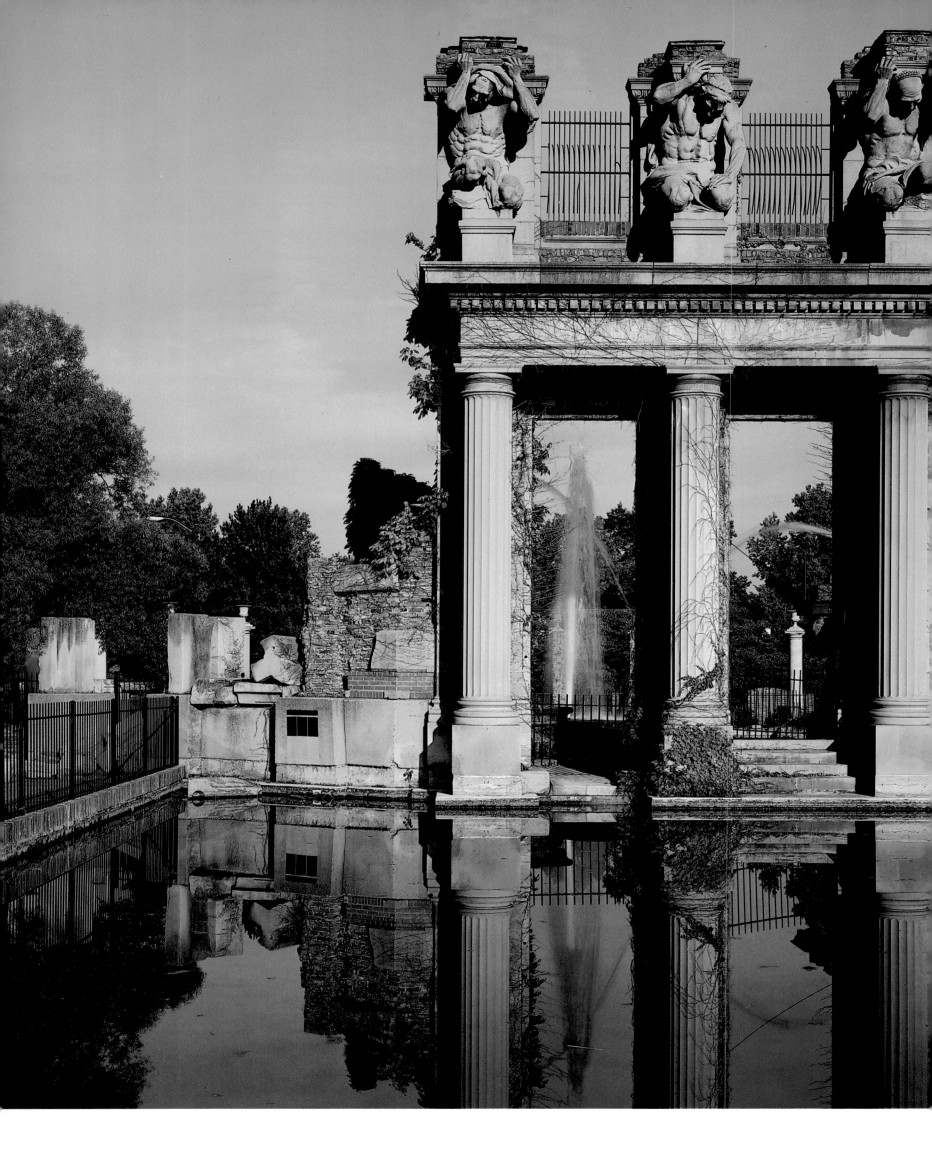

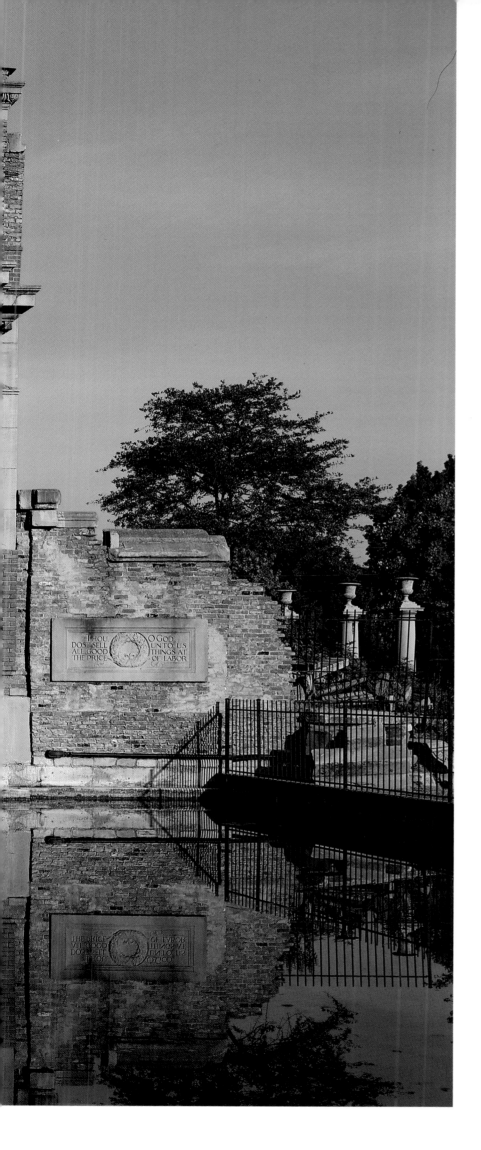

A couple of miles to the south of Holliday Park, Butler University enjoys a parklike atmosphere in this northwestern wooded section of its campus. The J. I. Holcomb Botanical Gardens are located along a segment of the Central Canal.

It must be a curious sight for those unfamiliar with the city's northwest side to drive by the entrance to Holliday Park (left) and to see these three stone statues perched atop their Doric columns. Salvaged from a building that was razed in New York City in 1958, they were awarded to Indianapolis thanks to the talents of artist and sculptor Elmer Taflinger. Taflinger submitted a design for a setting for these Karl Bitter statues and won the competition.

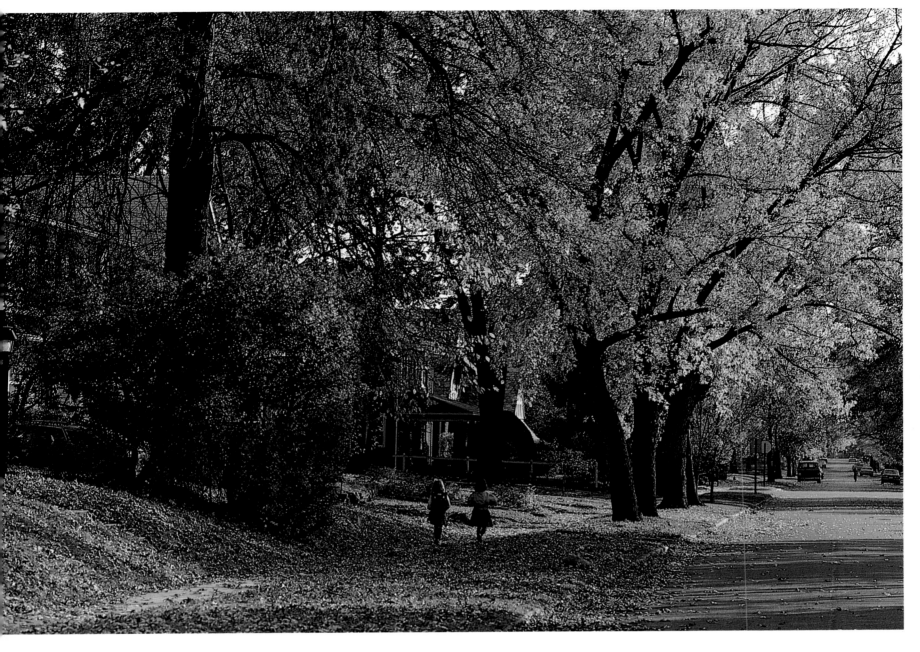

Two students walk along this tree-lined northside street, carrying their school necessities in backpacks. It makes us long for those carefree days, days we probably didn't fully appreciate at the time.

Young faces predominate in the front rows of this picture taken of a portion of the large congregation of the Second Presbyterian Church on North Meridian Street. The occasion marked the church's 150th year of existence in Indianapolis. The church was formed less than two decades after the city was established, and until 1959 its home was in the downtown area.

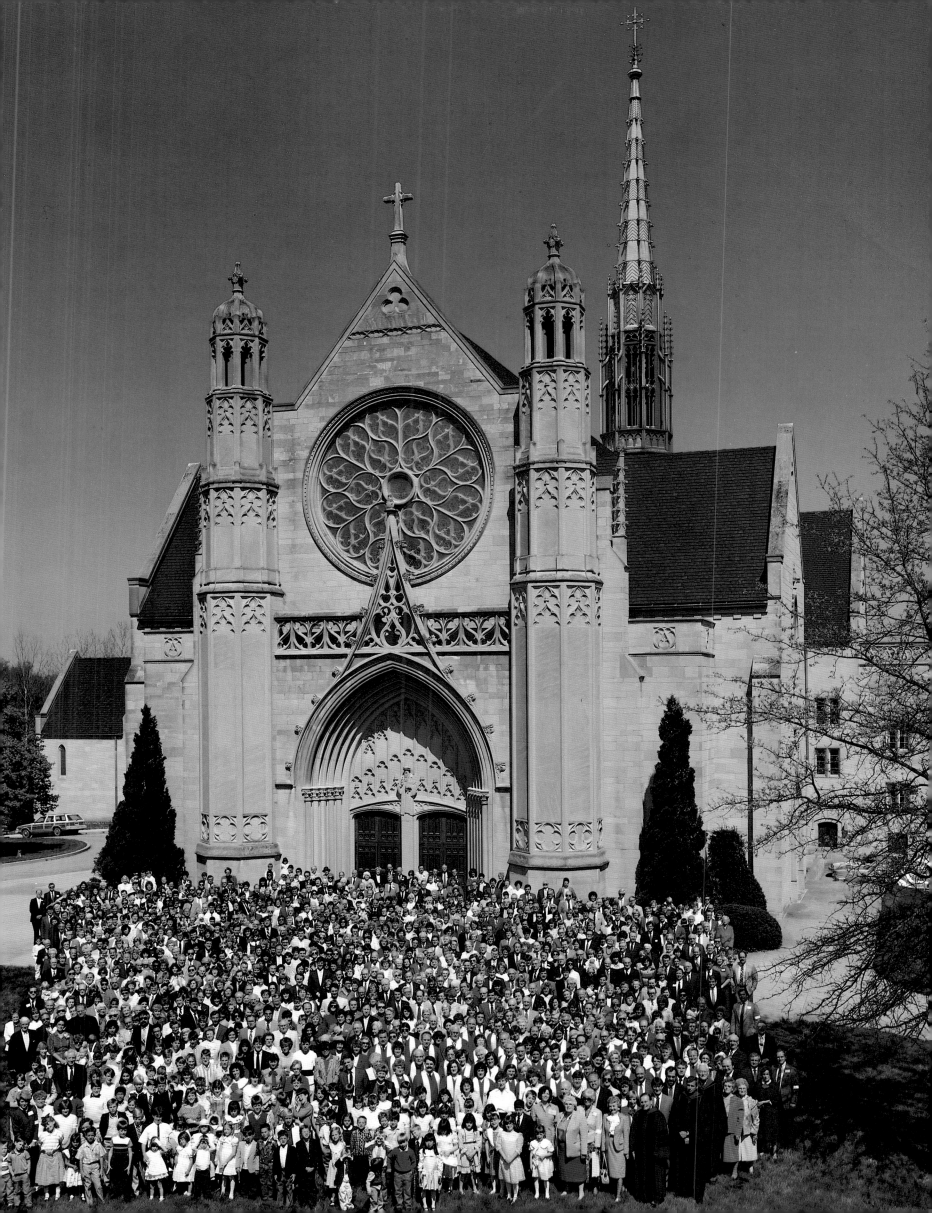

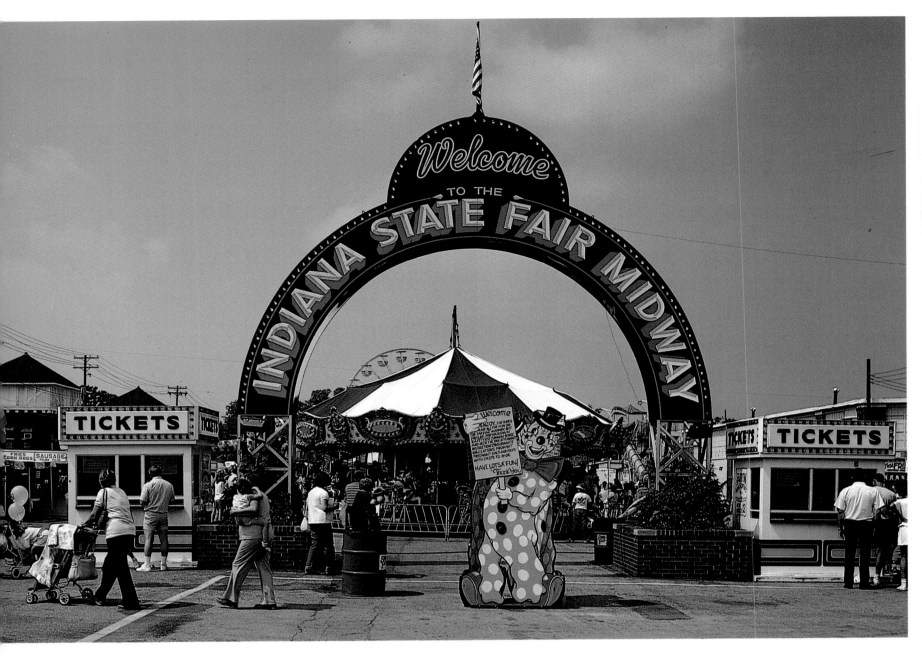

Indianapolis has been the site of the state fair most every year since the state started having it in 1852. One can only wonder how many Hoosier youngsters have walked through the midway entrance in happy anticipation of the adventures and thrills that await them. In their younger years a ride on the carousel (right) may be enough. The daring decisions come later.

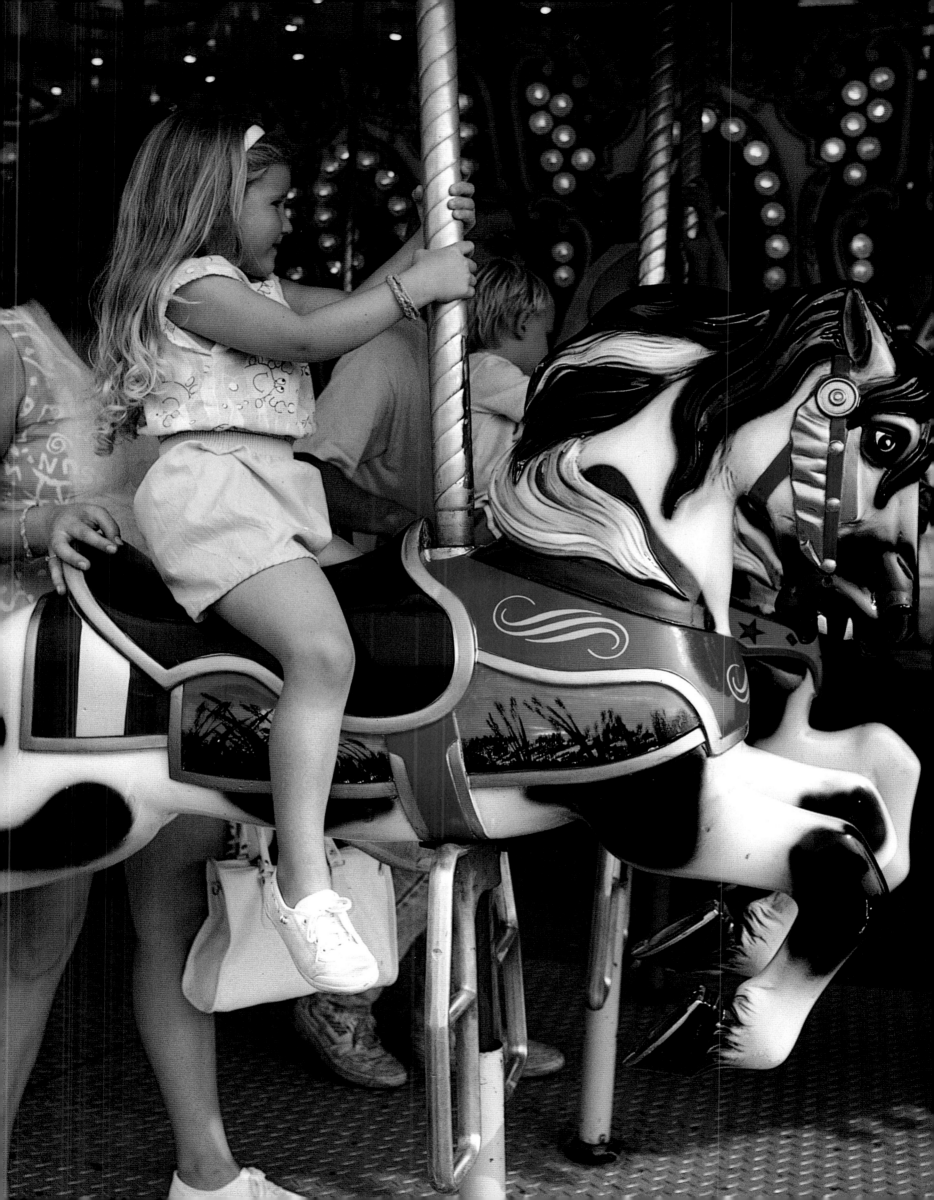

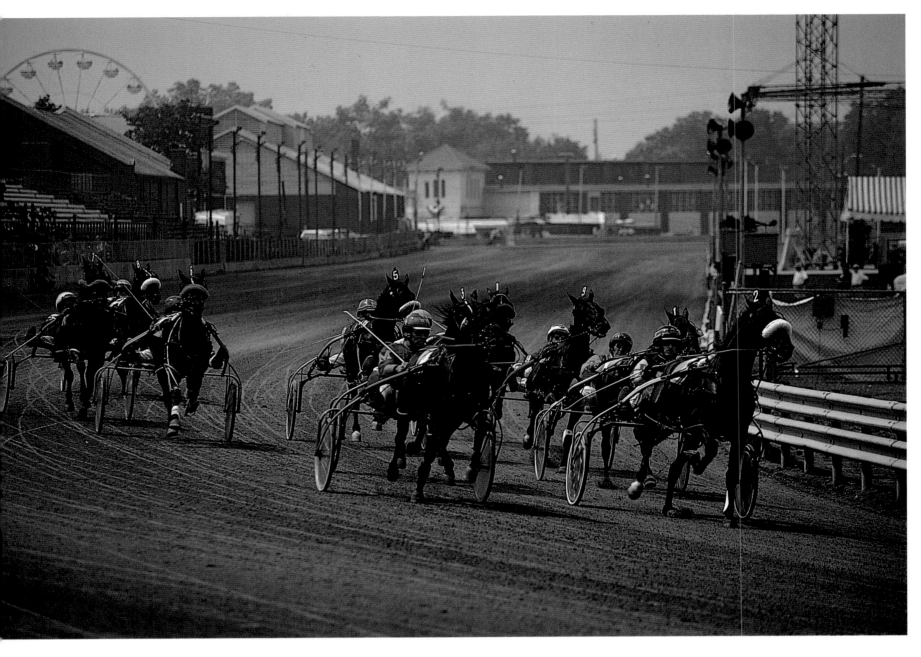

A state fair in Indianapolis means different things to different people. To lovers of horse track competition, it may mean traveling in from a far distance to see harness racing (left). Here these fans will find two of the oldest races in the country: the Fox Stake and the Horseman Stake for two-year-old pacers and trotters. To the younger set, a state fair may mean bringing animals in from the family farm and competing in tests of their entries' appearance and behavior. Sometimes an owner gets a little sleepy watching over a favorite—or two or three.

Irvington, on the city's eastside, is filled with a number of Victorian homes, very windy streets, and a variety of trees. This house (overleaf), just south of Irving Circle on South Audubon Road, is a fooler, however. It doesn't really date back to the nineteenth century. An owner simply saw to it that when it was restored, some gingerbread was employed.

Restoration has become fashionable in historic Irvington. The restorers of this house chose to leave the exterior true to its early twentieth-century look, but they added a banister to the porch.

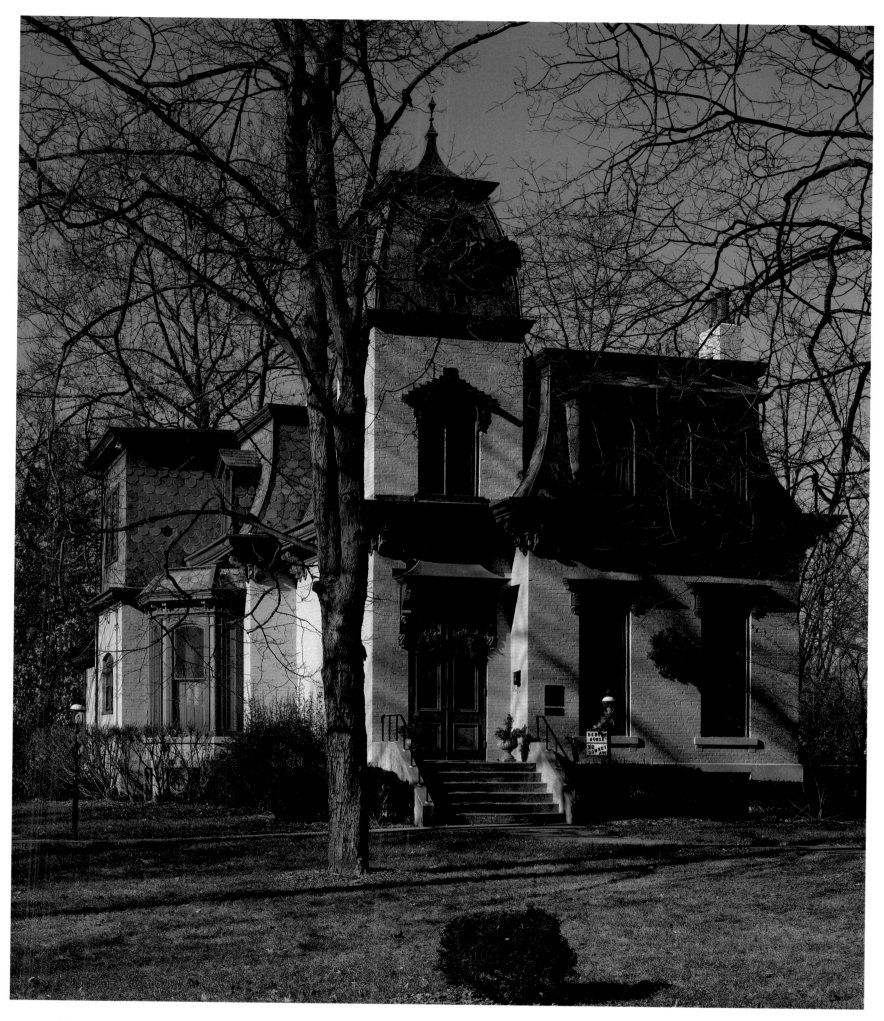

The Irvington Landmarks Foundation saved this brick home, known as the Benton House, because it was occupied for nearly two decades by a president of Butler University, Dr. Allen R. Benton. Near the old Butler campus, it is open to the public.

Just about the time Irvington was forming in the 1870s, another new neighborhood, Woodruff Place, was established. It was far closer to downtown, but like Irvington it was dedicated to privacy and gracious living. Fountains and statuary (above) were placed at every opportunity along esplanades that accompanied the three main drives through the area. Woodruff Place attracted some prominent citizens who built large homes in the 1890s.

This mansion in Irvington still reminds some of the greed and savagery of another time. In the 1920s it was the home of the kingpin of the Indiana Ku Klux Klan, D. C. Stephenson. At one point, it was claimed, D. C. controlled all branches of the state government and had considerable influence over the Indianapolis city government, too. Stephenson was convicted of murder in the rape and suicide of a young Irvington woman. He went to prison, and an era ended. His Greek Revival–style home on University Avenue near the old Butler campus looks much as it did when Stephenson lived there. It has been occupied for years by a private owner who restored the 1889 structure to its earlier dignity.

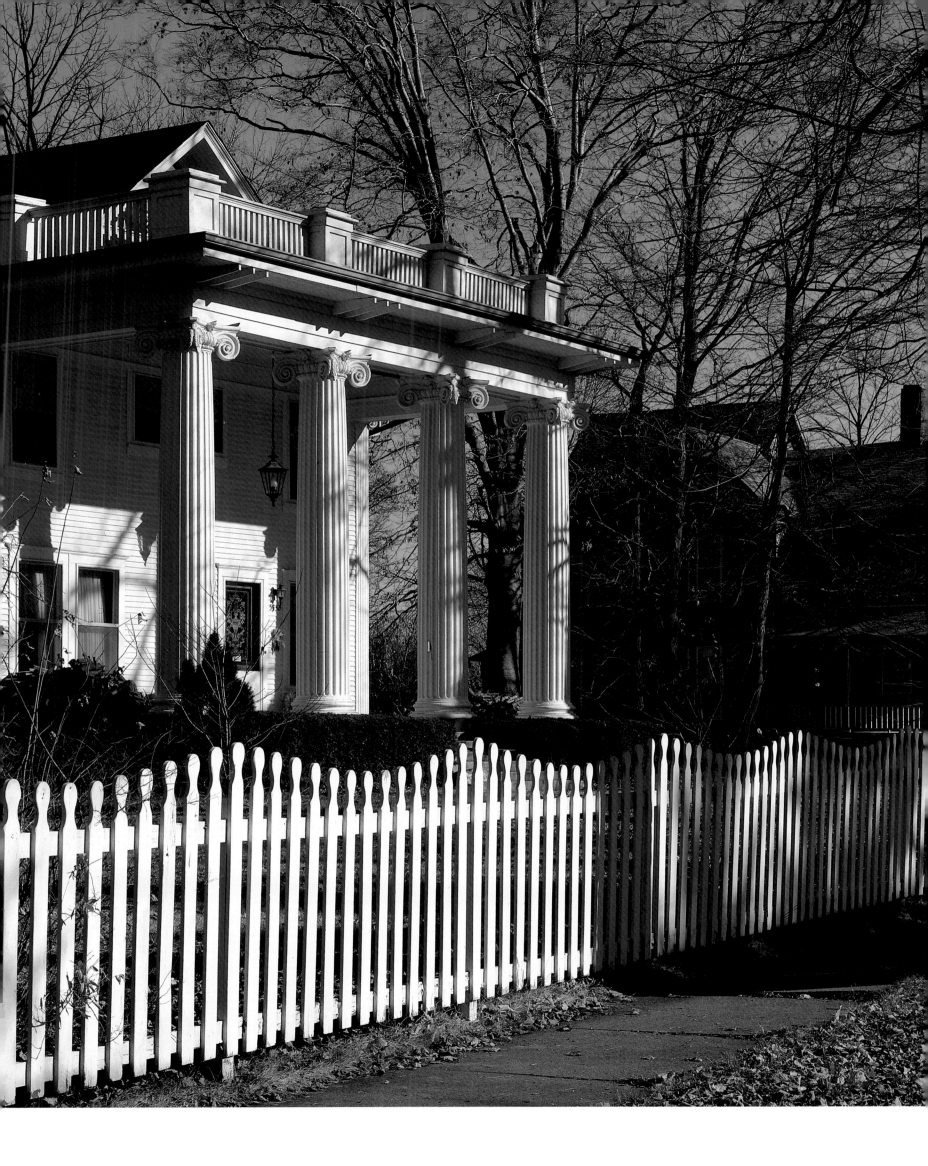

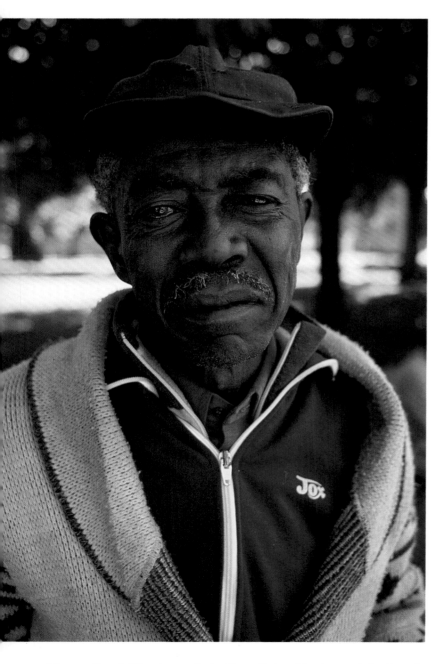

Above, floral life abounds in the city's oldest municipal park, Garfield Park, on the southside. Below, a retired veteran in University Park, downtown Indianapolis.

On the near southside, some small shop restorations, such as this one along Virginia Avenue, can be overshadowed by the bigger projects. Typical of a hardware store of a bygone era, it has been a background for several movies filmed in the city.

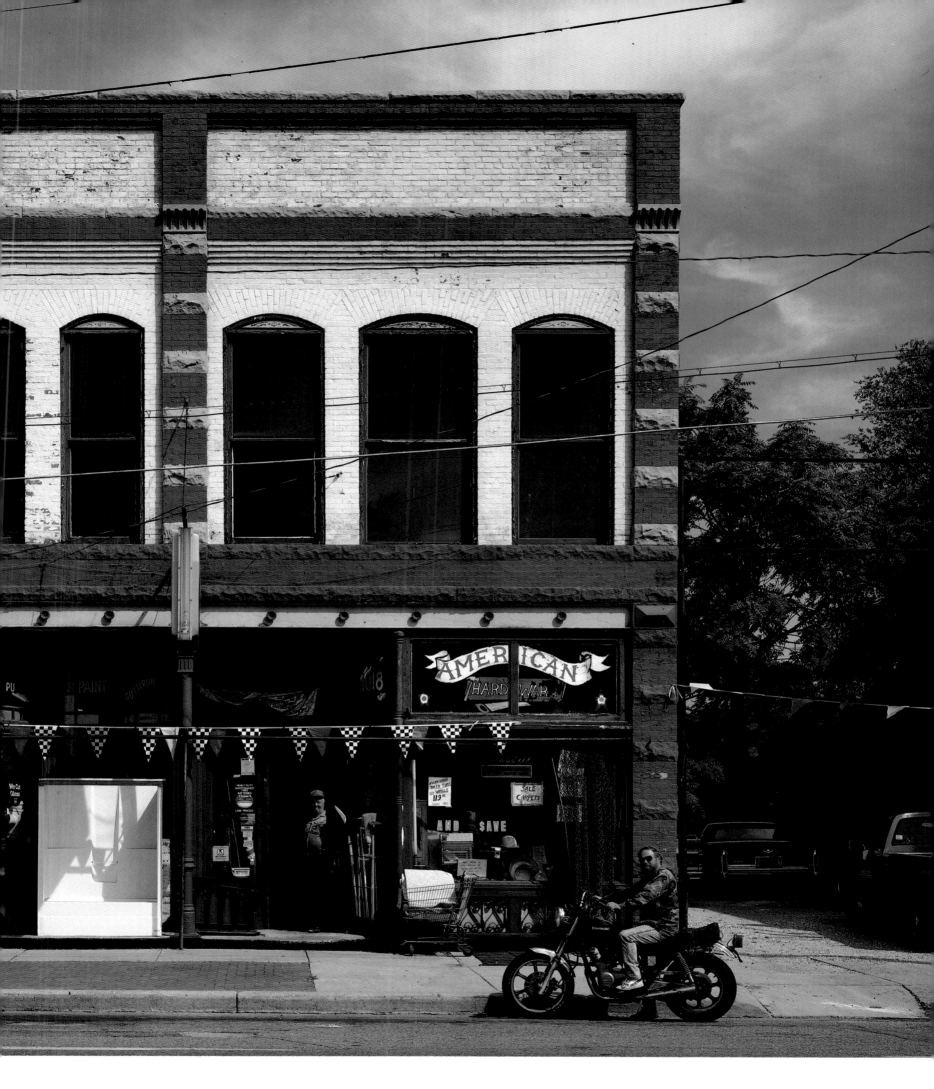

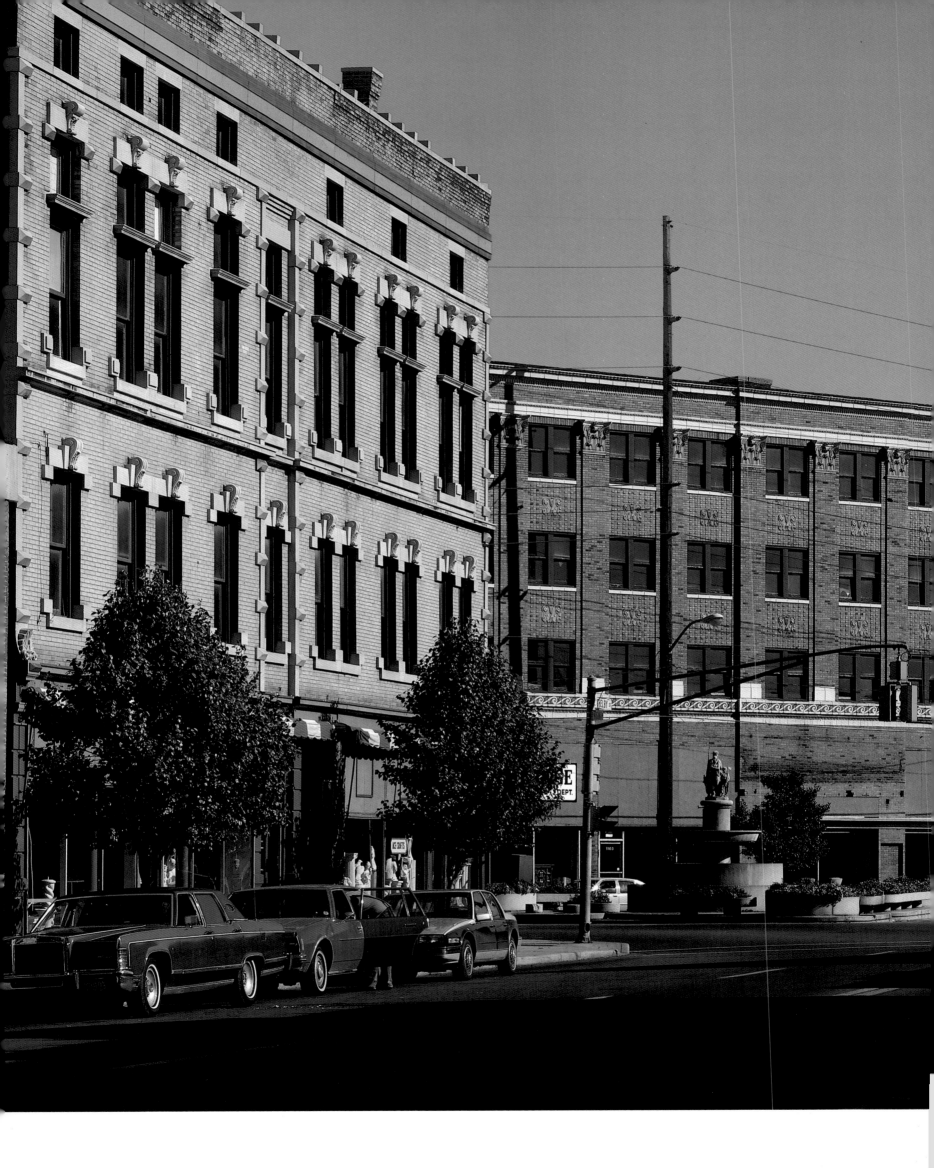

The city's basic street pattern encouraged construction of flatiron-style buildings such as this one. The shapes conform to intersections where avenues, angling from four directions into the downtown area, cross north-south or east-west streets.

Fountain Square, a near southside business area, is now a designated historic district. It was named for the fountain that was placed in the center of the main intersection to serve as a water trough for horses. The fountain is still there below the streetlight, having undergone reconstruction in the late 1970s. Behind it is the old Fountain Square Theatre building, which once housed not only a large theater but also a bowling alley. The sign atop the building used to proclaim proudly that this was Fountain Square Theatre, and it was visible from downtown. Now it is blank, supporting the remnants of an old soft-drink advertisement.

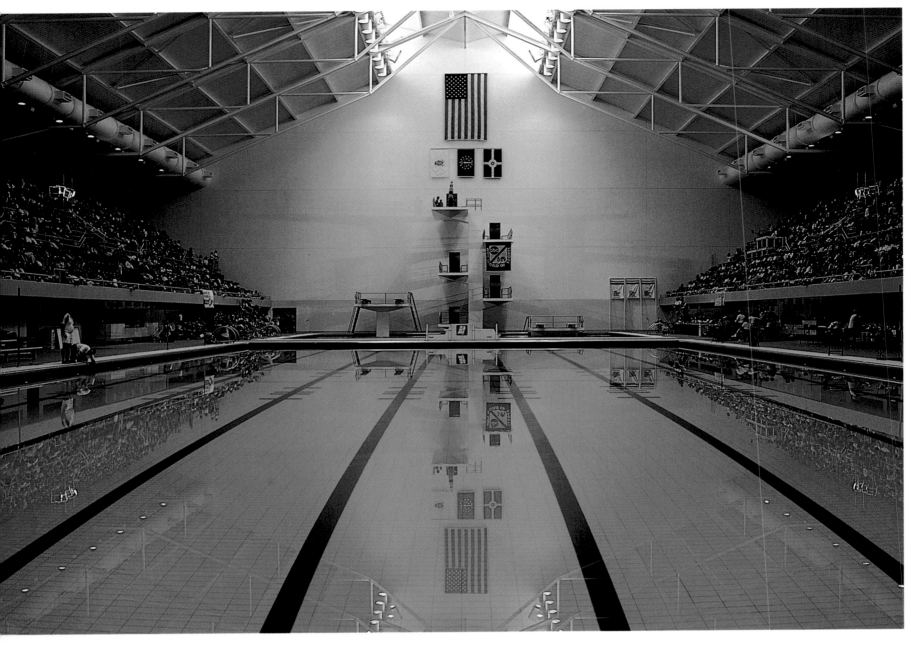

Two of the city's busiest athletic facilities are close to downtown and thus easily accessible to physical fitness buffs who work there. The facilities are also the scene of many collegiate and other top amateur competitions. The Indiana University Natatorium has two 50-meter pools, a platform diving pool, and a gymnasium. This shot was taken during Olympic Trials. The I.U. Track and Field Stadium, shown here during the Pan Am Games in 1987, has a 400-meter track with nine lanes. Both facilities provide adequate seating for spectators.

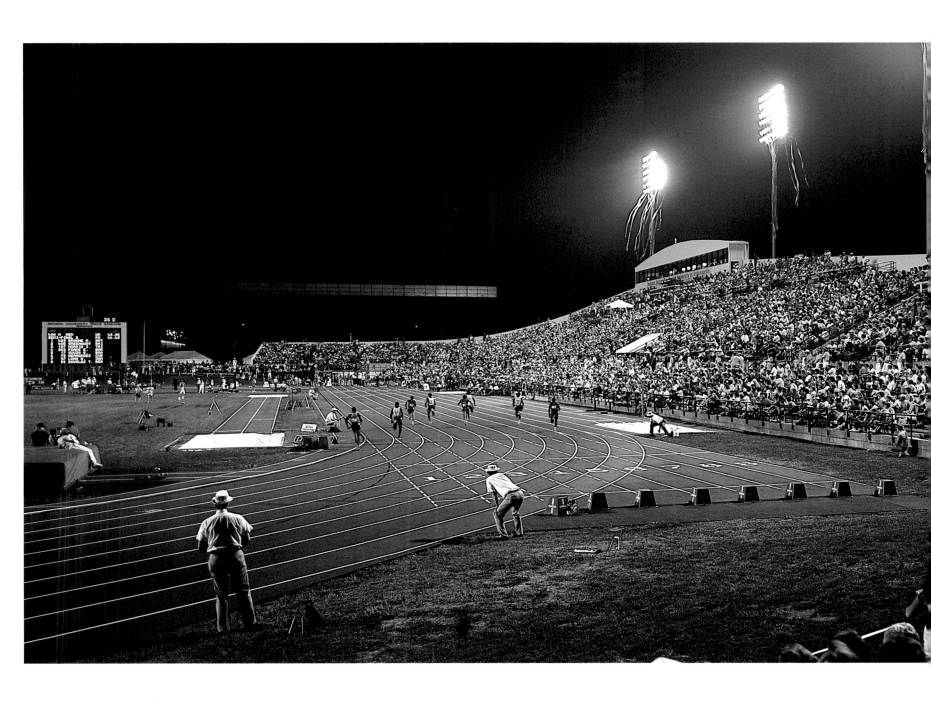

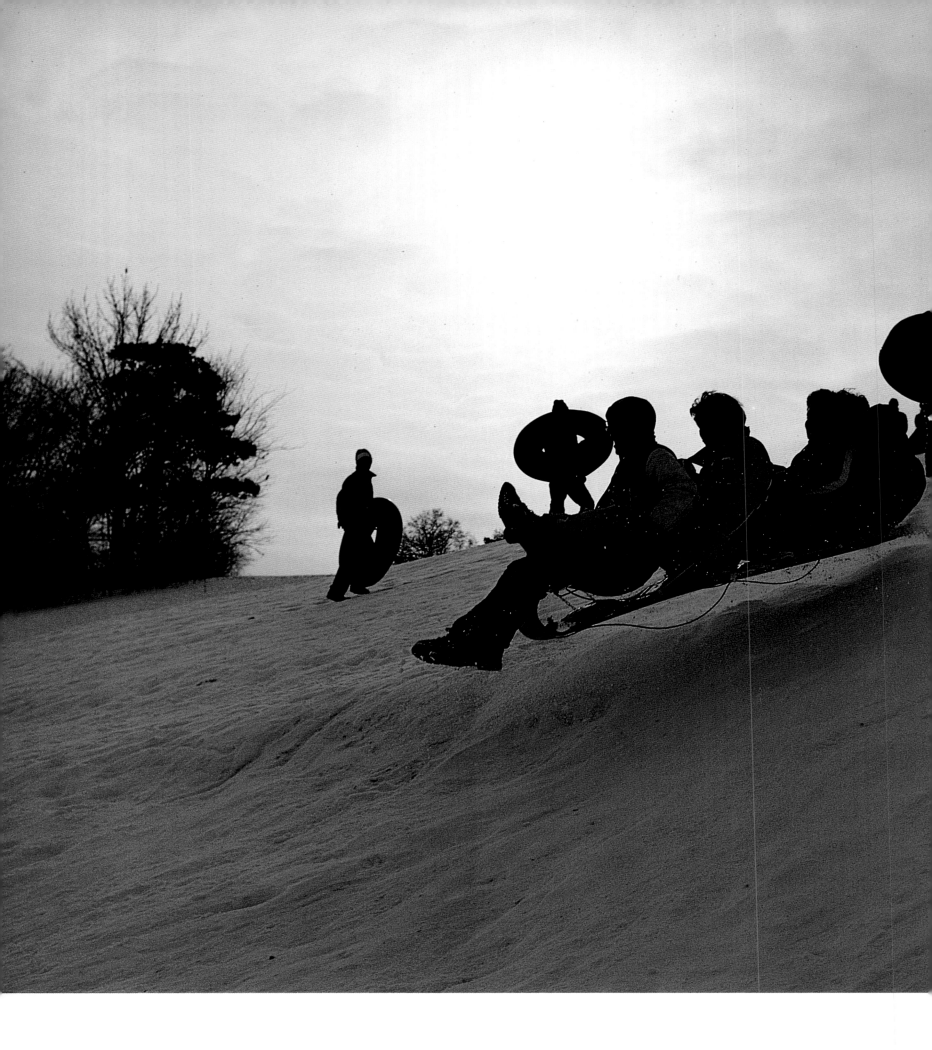

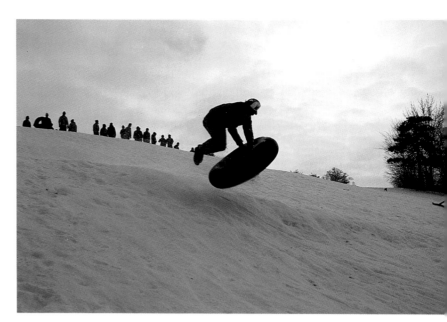

When snow and ice conditions are right, a favorite spot for the young, the bold, and the restless is a certain slope at the Riverside Golf Course on the city's westside. The kids call it "suicide hill." Photographer Jones said he related well to all that: he broke his ankle while sledding with his children when his courage got ahead of his logic. Tobogganing (left) and innertubing (top right) are common sights, and there are times when the adventurers take a semi-break in the action.

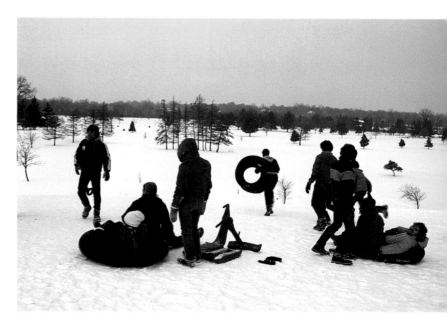

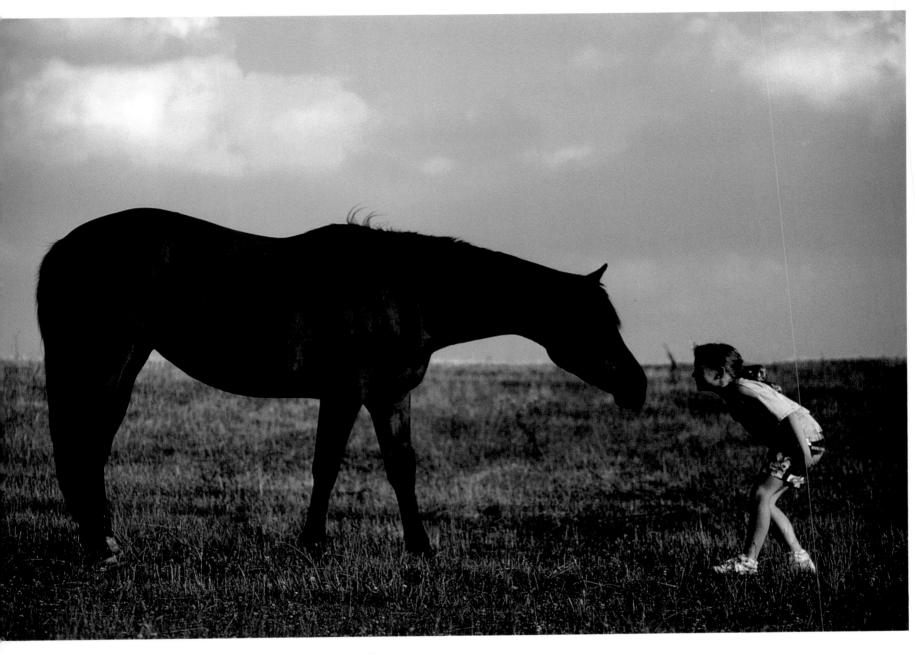

A young westside lady enjoys a conversation with a close friend. Horse ownership here is considerable. Twenty-four stables operate in the metropolitan area, providing training, trails, and space for boarding.

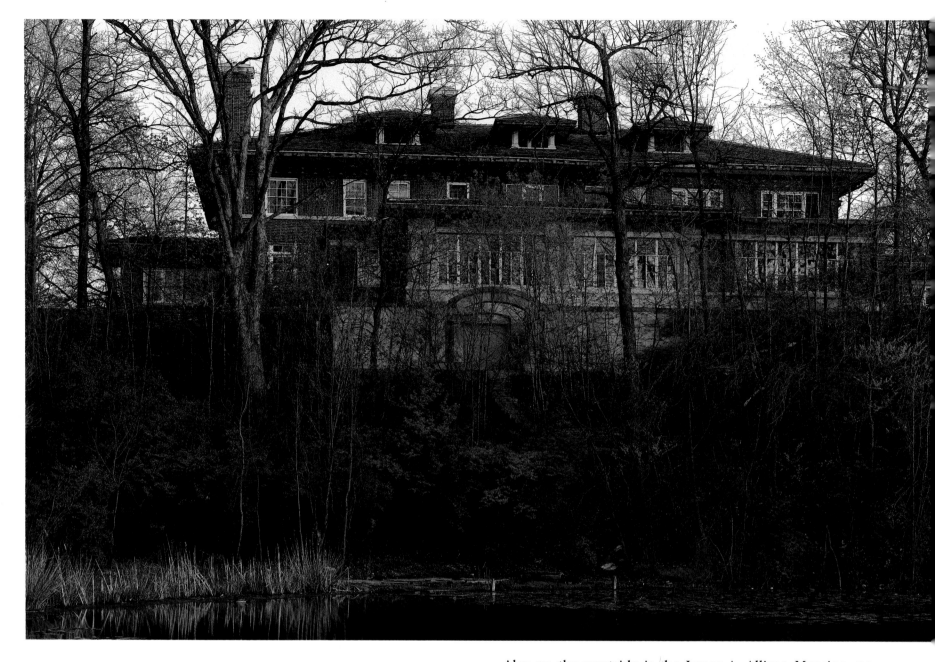

Also on the westside is the James A. Allison Mansion, now part of Marian College on Cold Spring Road. The redbud trees and the stream at the bottom of the stone steps add to the picturesque setting. Allison, a founder of the Speedway, was the owner of Allison Engine Company when he built the place in the early 1900s for two million dollars. It was called the "house of wonders" because it included a number of in novations, such as an indoor heated swimming pool.

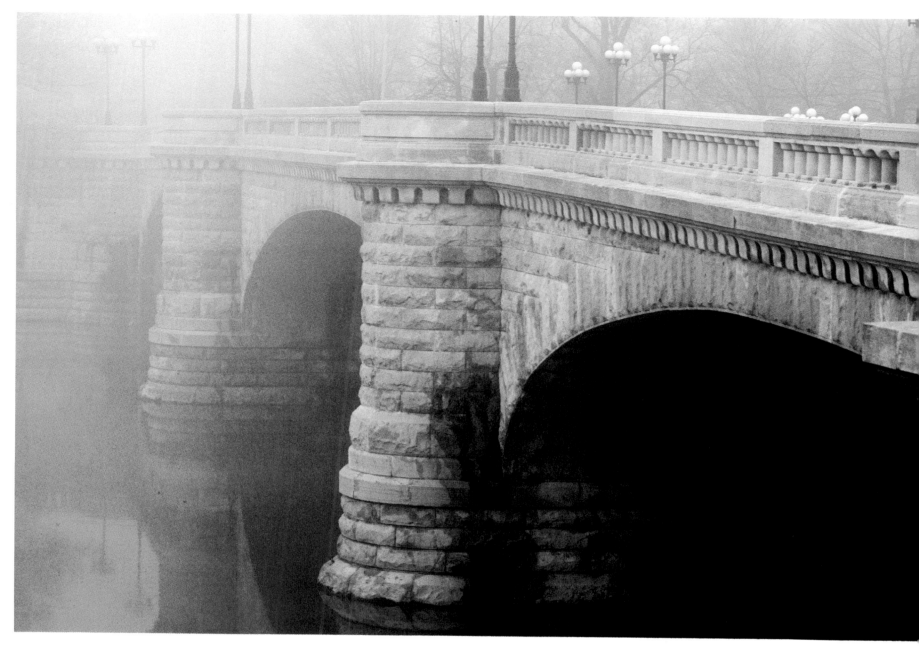

Parks of all sizes give the city character and have since its be-
ginnings. The newest and largest is Eagle Creek (left). In fact,
it's the largest park owned and operated by a city anywhere
in the United States. This shot obviously was taken in the fall,
for the leaves have their special autumn colors. The old stone
bridge spans White River on West 30th Street, less than a
block from the site of the old Riverside Amusement Park.
With the fog, it looks more like London than Indianapolis.

An appealing young face caught the photographer's attention when he happened upon a hayride that was on a brief rest stop at Eagle Creek Park. A few hours later, in the same general area of the city on West 38th Street, mechanized travel was in full force as workers headed home. It was a cloudy winter day, and headlights were required during rush hour.

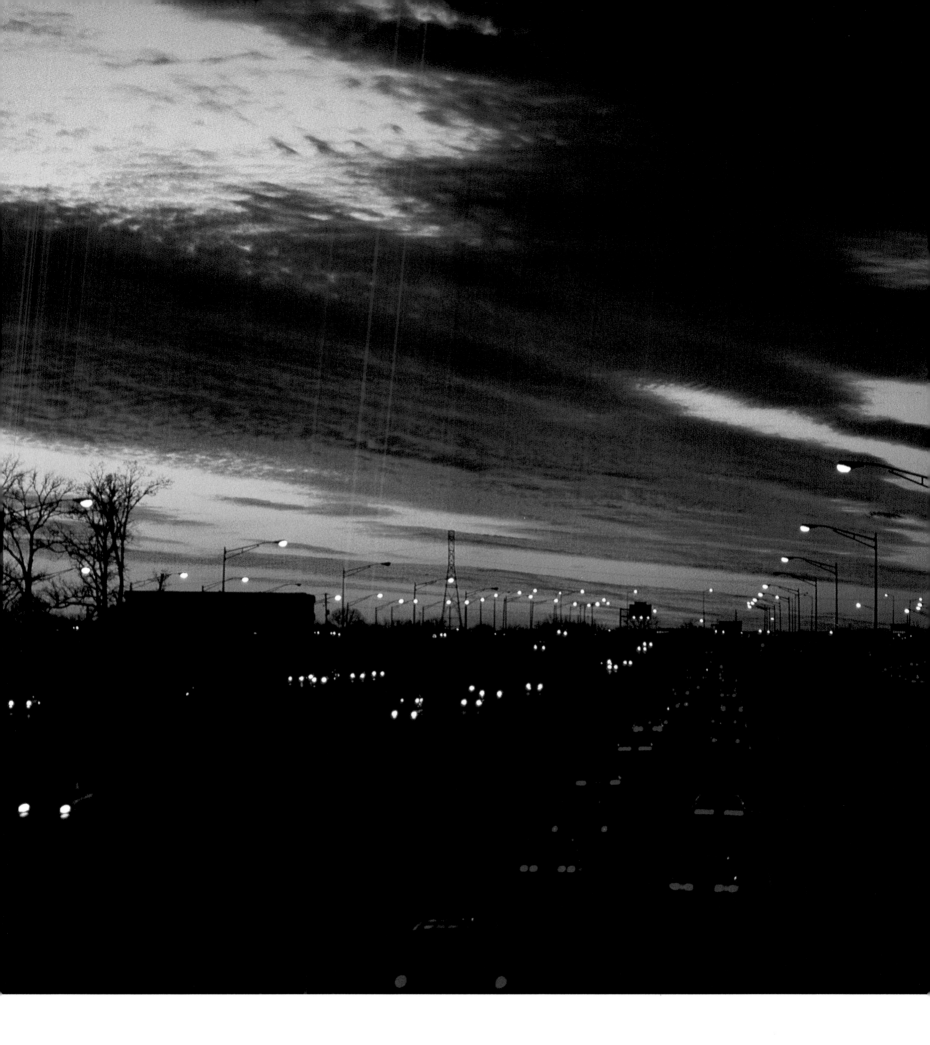

Two University of Indianapolis coeds walk by the school's first building, the Classical Revival—style Good Hall. The school was established as the privately endowed Indiana Central in the early 1900s but changed its name in the 1980s to be more closely perceived as a part of an energetic and growing city.

Sailboats beautify Eagle Creek Reservoir.

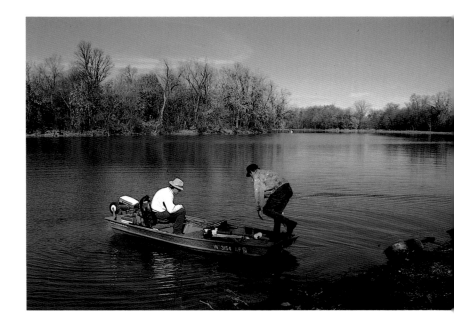

Not far away, a father and son see if they can find a little fishing business of their own (top right), and a pontoon boat operator takes a few customers out for a cruise and dining, a service he launched in 1989 for the mild-weather months.

A short distance from where Fall Creek flows into White River on the city's westside, one finds an activity not usually associated with Indianapolis. In the old neighborhood of Haughville is John's Fresh Fish Market, serving residents six days a week but never on Sunday—a schedule that once was the rule for local businesses rather than the exception. A small independent store such as John's is also coming to be a rarity.

109

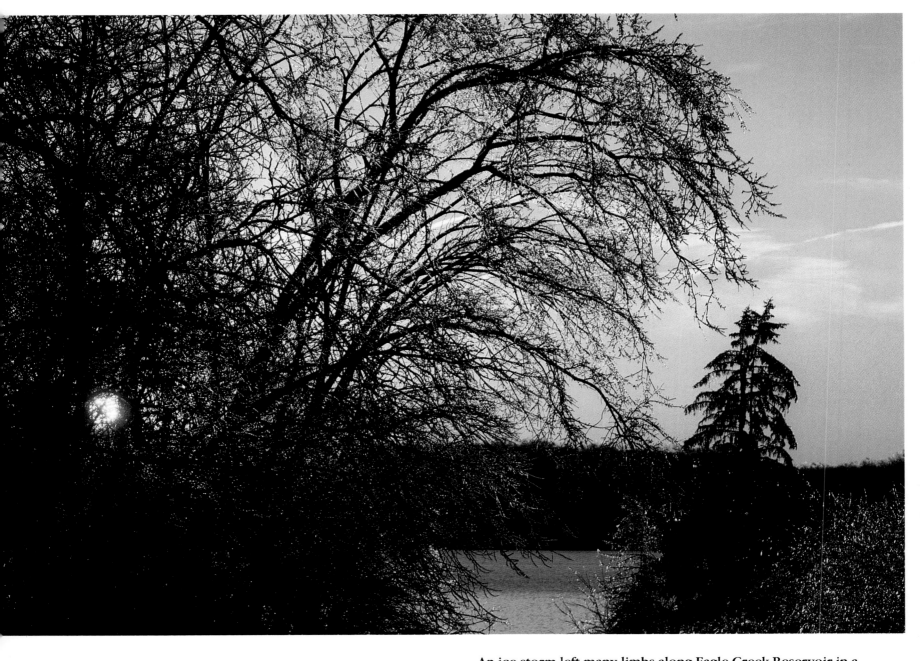

An ice storm left many limbs along Eagle Creek Reservoir in a petrified state for a few hours one wintry afternoon. The scenic effect came at sunset as the orb seemed to take one last peek before disappearing. And not many blocks from bustling downtown Indianapolis, deer frisk the year round in Eagle Creek Park—an unlikely contrast that lends a certain charm to the capital city.

Eagle Creek (preceding pages) was the basis for the big new park development in northwest Indianapolis in the mid-1960s. J. K. Lilly, Sr., protected the area when he bought 3,500 acres and kept it as a nature preserve. It was later donated to Purdue University, then sold to the Indianapolis Parks Department. One may boat, fish, picnic, swim, or play golf in the highly popular Eagle Creek Park.

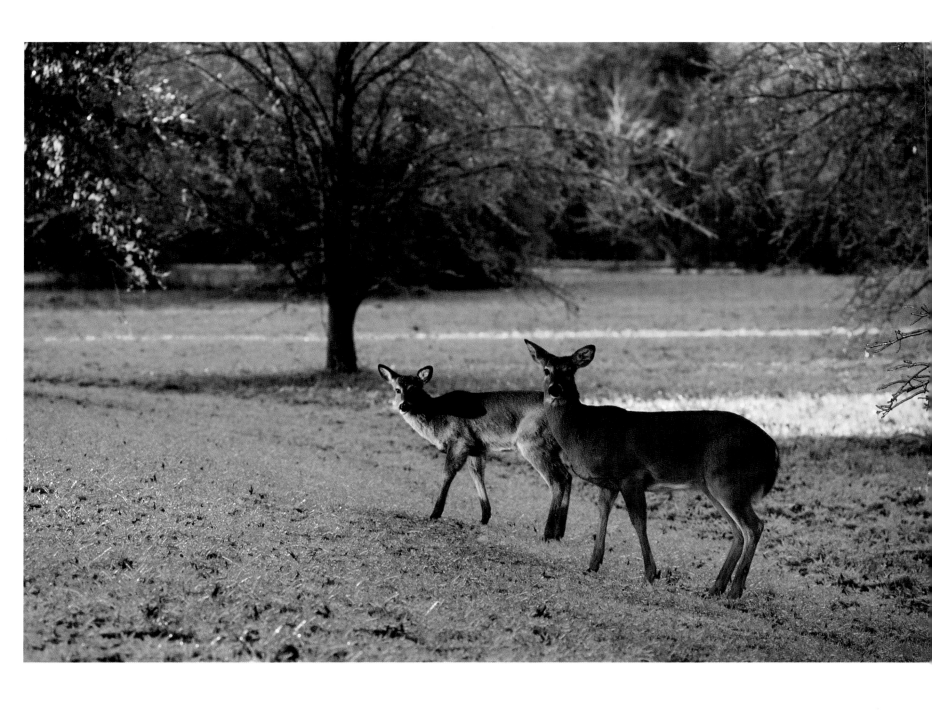

The Labor Day weekend fireworks display over White River has proved extremely popular in recent years. But there are some who say that the fireworks in Indianapolis are only beginning. Certainly it is safe to say that the city has picked up its tempo in the past three decades.

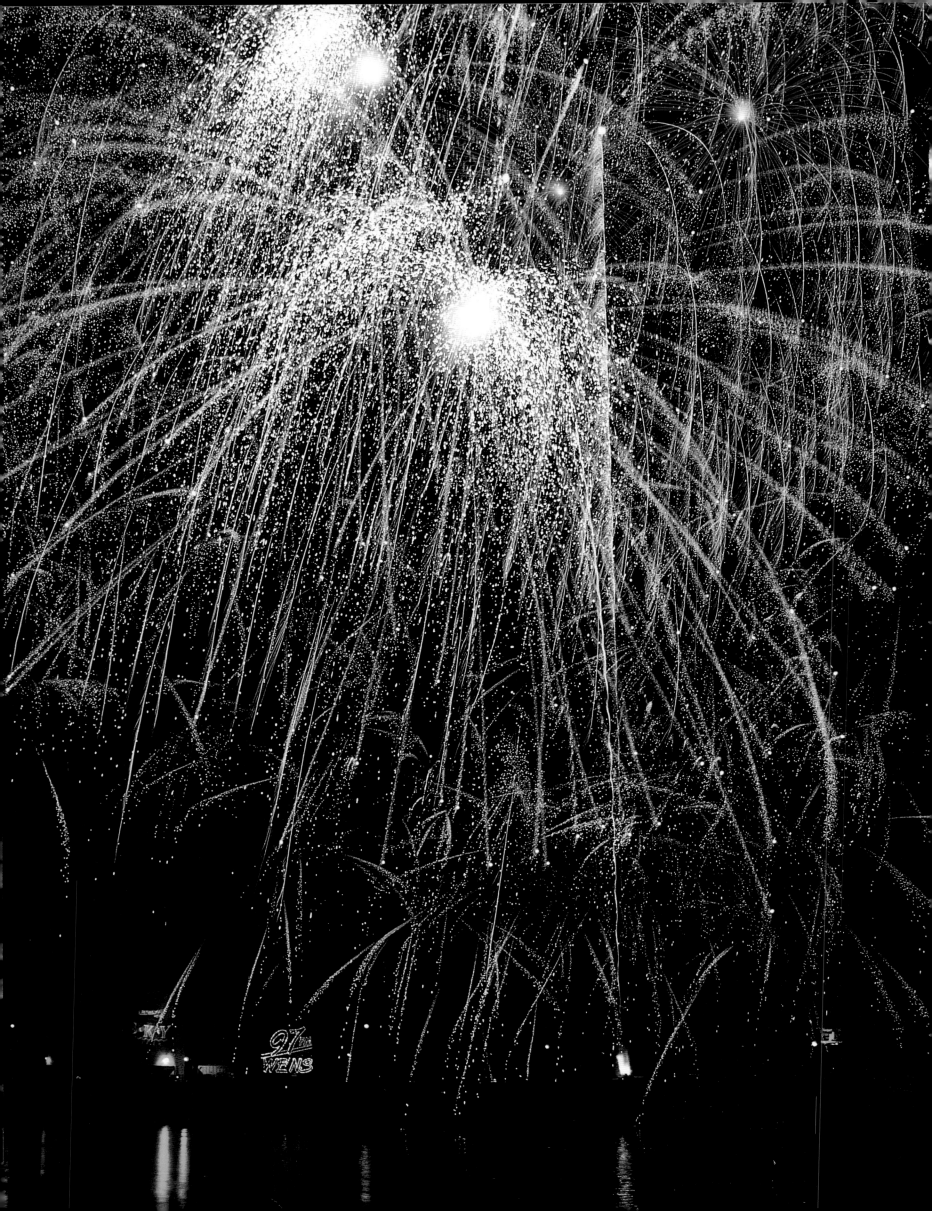